IN FOCUS

WEEGEE

D1219958

PHOTOGRAPHS

from

THE J. PAUL GETTY MUSEUM

Judith Keller

The J. Paul Getty Museum

Los Angeles

In Focus
Photographs from the J. Paul Getty Museum
Weston Naef, *General Editor*

© 2005 J. Paul Getty Trust

Getty Publications
1200 Getty Center Drive
Suite 500
Los Angeles, CA 90049-1682
www.getty.edu

Christopher Hudson, *Publisher*
Mark Greenberg, *Editor in Chief*

Library of Congress Cataloging-in-Publication Data

Keller, Judith.
 Weegee : photographs from the J. Paul Getty
Museum / Judith Keller.
 p. cm. — (In focus)
 ISBN-13: 978-0-89236-810-5 (pbk.)
 ISBN-10: 0-89236-810-1 (pbk.)
 1. Photojournalism—New York (State)—New York.
2. Weegee, 1899–1968. 3. J. Paul Getty Museum—
Photograph collections. 4. Photograph collections—
California—Los Angeles. I. Weegee, 1899–1968.
II. J. Paul Getty Museum. III. Title. IV. In focus
(J. Paul Getty Museum)
 TR820.K4293 2005

 2005011496

Contents

Foreword

Long before Andy Warhol donned his signature platinum wig, Weegee became famous for being famous. He first gained fame for materializing on the scene, Speed Graphic camera in hand, within moments of a Manhattan accident, fire, murder, or robbery. He happily gave interviews to the magazines that bought his pictures and propagated his image as a daring underworld photographer. After the publication of his first book, *Naked City*, in 1945 and the release of the film noir hit of the same name in 1948, Weegee's selling of himself increased, along with his compensation from camera manufacturers and his work in advertising, fashion, and Hollywood. In an attempt to remind New York that Weegee the Famous was still around, he published a sensationalized autobiography, *Weegee by Weegee*, in 1961. By then, the press pictures that had made him a storyteller on a par with the contemporary writers Joseph Mitchell and Damon Runyon were nearly forgotten.

This book on Weegee was realized through the efforts of staff of the Department of Photographs. I especially thank Judith Keller, who managed the project and wrote the text. Michael Hargraves catalogued the Getty collection, drafted the chronology, and assisted with research. Julian Cox ensured the documentation of the pictures. Marisa Weintraub handled the logistics of the colloquium.

Photographers Sid Kaplan, Walter Rosenblum, and Delmar Watson generously shared reminiscences about Weegee's character and career. Miles Barth, author of *Weegee's World* (1997), answered questions about the photographer's biography and estate. The staff at the Center for Creative Photography (Tucson), the Metropolitan Museum of Art (New York), and the New Orleans Museum of Art provided information about their significant Weegee holdings. Great appreciation goes to Cynthia Young, Assistant Curator at the International Center of Photography (New York), for her help with research in the Weegee archive. She and Chris George, Cataloguer, patiently produced files and pictures for the author during her several visits there.

William M. Griswold
Acting Director and Chief Curator
The J. Paul Getty Museum

Introduction

In 1935, the year Weegee quit Acme Newspictures and declared himself a free-lance photographer, Lucky Luciano (1897–1962) had his rival Dutch Schultz (1902–1935) killed, quickly expanding Luciano's notoriety and the grasp of his new crime syndicate. New York gangsters would provide ample material for Weegee on his self-assigned police beat; he boasted that he was the official photographer for Luciano's Murder, Inc. Another event of 1935 may have had a larger impact on this ambitious cameraman, however. *The Breathless Moment: The World's Most Sensational News Photos*, presenting about 250 images assembled over two years from collections around the world, was published by Alfred A. Knopf. Weegee had other possible sources of inspiration, from the picture journalism of the popular tabloids to illustrated books on New York, such as *Metropolis: An American City in Photographs* (1934), with images by the anthropologist-photographer Edward M. Weyer (1904–1998). But the pictures of accidents, crimes, and natural disasters compiled in *The Breathless Moment* set a powerful example.

Born in 1899 in what was then Lemberg, Austria, Usher H. Fellig immigrated with his mother and siblings to New York in 1910. They settled in the Jewish community of the Lower East Side, where his father, who had immigrated in 1906, was making a meager living. Now called Arthur, Fellig endured only a few years of public school before looking for employment and a future occupation. Deciding on photography, he worked as a tintype operator, assisted at a commercial studio in Lower Manhattan, and took on the maintenance of a pony, Hypo, and a five-by-

seven-inch camera in an effort to earn money as an itinerant portrait photographer. Although useful experience, photography with Hypo became too expensive. Fellig then had a series of short-term jobs, including busboy, dishwasher, and candy mixer before starting a new succession of positions related to photography. He served a three-year stint in a photography studio and performed darkroom work at the *New York Times*. About 1924 he began a steady job in the darkroom labs of Acme News-pictures (later United Press International Photos) that would involve a tour of duty in Los Angeles covering the 1932 Summer Olympics. During his time at Acme, Fellig processed and printed all varieties of news photographs and occasionally went out to cover fires and other late-night disasters when no one else was available.

The mid-1930s proved a good time to go freelance. New York had at least eight increasingly illustrated daily newspapers, and the picture agencies (news syndicates) were busier than ever, since images could be instantly wired around the world. In addition, detectives, G-men (agents of the new FBI), mobsters, and even crime photographers were Depression-era celebrities, thanks in part to Hollywood, the tabloids, and pulp fiction. Fellig, now known as Weegee (because of his seemingly psychic ability to be the first on the scene), fit the contemporary profile of antihero perfectly: an unshaven, tough-talking, fedora-wearing, cigar-smoking loner who lived in one room and worked at night. And his nights were very busy. Having finally learned to drive, he dashed around the city responding to the police radio, tips from reporters (they sometimes traveled together), cues from informers, or his own intuition about impending newsworthy events. Once he and his bulky Speed Graphic camera had obtained a sufficient record of the night's calamities, he quickly produced prints and sped around town from editor to editor, picture agency to picture agency, selling his images to those responsible for the New York morning papers or the next edition on the other side of the globe.

By 1937, Weegee himself was national news. In its April 12 issue, *Life* magazine published thirteen images, including several of the photographer, in the section "Speaking of Pictures: A New York Free Lance Photographs the News." A self-portrait of the daring, first-on-the-scene bachelor, posed with a mannequin, is captioned, "Fellig has no home, no wife, no family, doesn't seem to want any." *Popular Photography*, in its first year of existence, ran a long December profile on this "Free-Lance Cameraman," making his job sound glamorous: "Grabbing hot

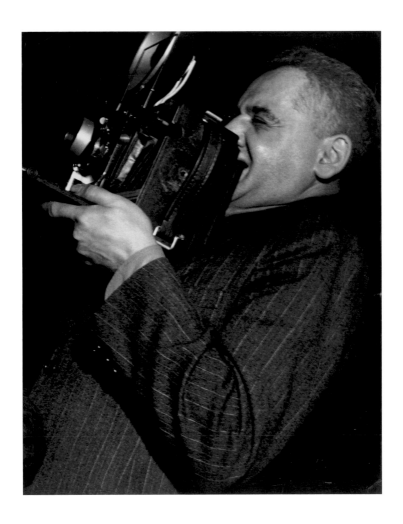

Lisette Model (American, b. Austria, 1901–1983).
Weegee, New York, 1945. Gelatin silver print,
34.1 × 27 cm (13⁷/₁₆ × 10⁵/₈ in.). 84.XM.153.75.
© Lisette Model Estate, courtesy Baudoin Lebon / Keitelman.

news pictures has become an exciting and profitable occupation for New York's Arthur Fellig. This story of his work is packed with thrills." Weegee's own words toward the end of the article were unusually modest: "Sure. I'd like to live regular. Go home to a goodlooking wife, a hot dinner, and a husky kid. But I guess I got film in my blood. I love this racket. It's exciting. It's dangerous. It's funny. It's tough. It's heartbreaking."

Weegee's acclaim in the media, as well as the quality of his pictures, landed him a regular client—the adventurous newspaper *PM*, which began publication in 1940. With a tabloid format but broadsheet depth and exceptional literary standards, this politically progressive paper ran Weegee's picture stories, sometimes with his words, until its demise in 1948. Weegee's association with writers and photographers at *PM* started about the same time as his involvement with the leftist group the Photo League, which sponsored photography classes, lectures, and exhibitions. Weegee contributed to all these activities; his first one-person show, *Weegee: Murder Is My Business*, took place in the League's space in 1941.

When Weegee's first book, *Naked City*, appeared in 1945, *PM* proudly printed a review on July 22 by the photographer-filmmaker Paul Strand (1890–1976), a prominent member of the Photo League. He refers to *The Breathless Moment* by way of acknowledging that many other photographers "have caught, in midair, so to speak, the fleeting drama of innumerable events," but he defends Weegee as the first to use day-to-day photojournalism "as a creative medium." Strand argues, "Weegee's distinction lies in the fact that he has produced a large and consistent body of work, one which is tied together by an individual attitude toward everything he photographs." Strand doesn't, however, comment on the curious fact that the prosperous Madison Avenue publisher Duell, Sloan and Pearce issued the volume under its Essential Books imprint. This surprising collaboration may have occurred at the suggestion of *New Yorker* writer Joseph Mitchell (1908–1996), whose collection of twenty "low-life" profiles, *McSorley's Wonderful Saloon*, was published by the firm in 1943. The piece Mitchell was said to have prepared on Weegee (and Weegee on Mitchell) never seems to have appeared.

The photographer's career had taken a new turn. He was not only creating books but also consulting on films and acting in them. His contributions to the screen version of *Naked City*, for which Universal bought the title rights, evolved

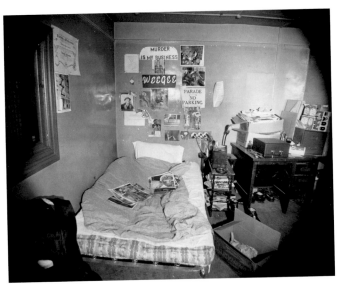

Weegee.
Weegee's Office-Apartment, 5 Center Market Place, New York, ca. 1939.
Gelatin silver print, 18.9 × 23.7 cm (7⁷⁄₁₆ × 9⁵⁄₁₆ in.).
International Center of Photography, 19201.1993.

into regular technical consulting on movies from the late 1940s into the 1960s. In addition to advising on special effects, he was given small parts and asked to do cross-country publicity tours, such as that for Universal's *The Sleeping City* (1950). This meant interviews on radio and television, a wide lecture audience, national exposure for his crime pictures, and offers to advertise camera equipment. Now a spokesman for photographic supplies as well as a highly paid advertising photographer, Weegee traveled between Hollywood, New York, and Europe, with stints on British and Parisian papers that would sustain him into the 1960s.

Weegee became a hero to amateurs, a fixture at trade fairs, and an author of how-to photography books. The creative possibilities of various darkroom techniques became his highest priority, edging out everything except an indulgence in pinup photography. His celebrity extended to Times Square modeling studios and the culture of men's magazines, one of which he edited and later claimed

to have filled with his own pictures under a variety of names. His 1961 autobiography, *Weegee by Weegee*, with a dust jacket that billed him as "The World's Zaniest Photographer," appears to have been an effort to resuscitate his status in New York, to let "the advertising agencies and the other photographers know that Weegee is back in town!"

Weegee made thousands of photographs and never filed any of them. He saved them, however, and his companion in his last years, Wilma Wilcox (1903–1993), continued to protect them after his death in 1968. Wilcox had help in her efforts to maintain Weegee's legacy. Two New York artists, Louis Stettner (b. 1922) and John Coplans (1920–2003), published articles and books about his work in the 1960s and 1970s. The New York gallerists Marcuse Pfeiffer and Daniel Wolf presented his images to the young photography market in 1976 and 1980, respectively. In the West, the newly founded Center for Creative Photography (Tucson) mounted a 1975 retrospective and acquired 173 prints for its collection. At Wilcox's death, the bulk of the pictures in Weegee's estate, more than 20,000 prints spanning his career, went to the International Center of Photography in midtown New York, not far from the Times Square area he loved.

The Getty Museum's collection of 95 photographs made by Weegee between 1937 and 1959 has been assembled from a variety of sources. Most of the holdings were acquired in 1984 from the Coplans collection through the Daniel Wolf Gallery. In the past twenty years, works have been added from U.S. and European sources, including a 2004 gift from David Raymond of New York. These acquisitions encompass a group of images apparently made for a book on Greenwich Village that failed to find a publisher during Weegee's lifetime; several 1940s pictures employed in the book *Weegee's People* (1946), which hastily followed the success of *Naked City*; and an inscribed print of Marilyn Monroe atop a pink elephant.

Judith Keller
Associate Curator, Department of Photographs

Plates

Note to the Reader

These prints, made from negatives that
date from 1937 to 1959, have been
arranged by subject matter rather than
chronologically.

The publication dates of Weegee's
photographs in the popular press are
generally used here to assign dates
to the negatives, which may have been
made earlier.

Titles are generally assigned based upon
those published in the popular press or
in Weegee's books or inscribed on the
prints. Idiosyncracies in titles and quoted
passages are retained.

PLATE 1

**Simply Add
Boiling Water**

ca. 1950 gelatin silver print
from a 1937 negative
33.7 × 26.3 cm
(13¼ × 10⅜ in.)
84.XM.190.33

PLATE 2

Conflagration

ca. 1940

Gelatin silver print
26 × 33.8 cm
(10¼ × 13⁵⁄₁₆ in.)
84.XM.190.17

PLATE 3

**Watching a Fire /
War Plant and
Furniture Warehouse,
E. 36th St., Burns**

March 1944

Gelatin silver print
27.2 × 33.6 cm
(10¾ × 13¼ in.)
2003.99.10

George N. Barnard (1819–1902), a daguerreo-typist, made what is thought to be the first American news photograph in July 1853. The subject was a blaze that destroyed the flour mills at Oswego, New York. Commercial and residential fires were frequent, but still newsworthy, events in Weegee's densely populated New York City nearly a century later. Coney Island's Dreamland amusement park even featured two daily shows of simulated tenement fires (in the off-season, unemployed sideshow characters were hired by the Mob to commit arson). Fires were news, entertainment, and a serious subject with amateur photographers.

Weegee's self-titled image of the burn-ing American Kitchen Products building that bears a Hygrade Frankfurters billboard (pl. 1) was used in a July 1937 *Minicam Photography* how-to article with the caption: "The sign across the center of the building refers to the frankfurters, not the firemen! Weegee put his Speed Graphic with 5¼" lens

on a tripod and three No. 3 flashbulbs on extensions." Plate 2 seems to illustrate the advice the artist gave in his 1953 book *Weegee's Secrets of Shooting with Photoflash.* Under "A Photographer's 'Place' at a Fire," he warned: "Watch out for fire hose . . . Many a photographer has broken his neck or camera . . . or both, tripping over hose which lie in the streets. This is easy to do when your eye is glued to the view finder and you move into position for a shot."

A 1945 *Look* series on "The Nature of Human Behavior" was illustrated with Weegee's news images and included discus-sion in the August 7 issue of a trait he was guilty of himself, "Morbid Curiosity." Plate 3 records a crowd that lingered in the cold for hours to watch the progress of an industrial fire. Both young and old were fascinated by the destructive flames, and, for a moment, the schoolboys in the foreground were trans-fixed by Weegee's camera.

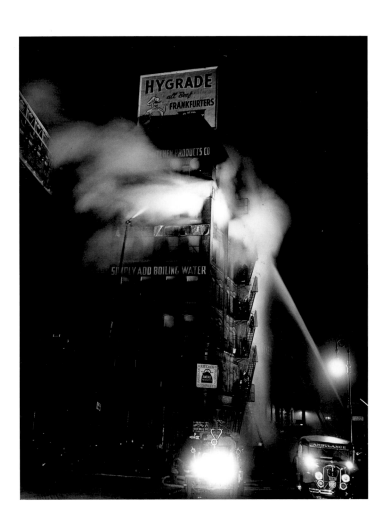

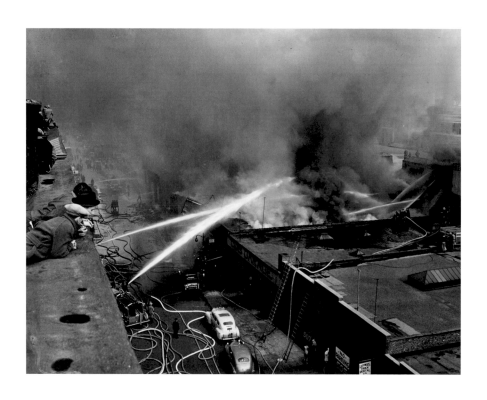

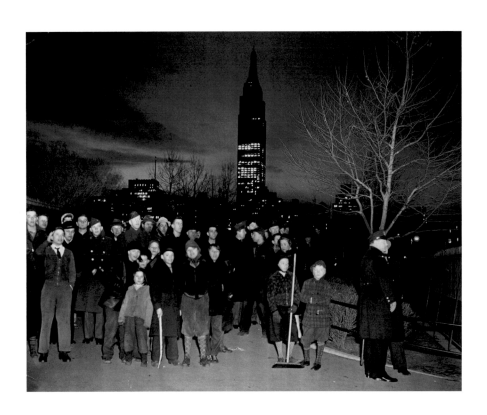

PLATE 4

I Cried When I Took
This Picture

ca. 1950 gelatin silver print
from a December 14, 1939,
negative
26.5 × 34.4 cm
(10⁷⁄₁₆ × 13⁹⁄₁₆ in.)
84.XM.190.45

On December 14, 1939, eleven families were
forced into the street at two in the morning
as a fire raged through their tenement house
in Brooklyn. Mrs. Henrietta Torres and her
daughter Ada were among those who fled
to the sidewalk. Two relatives of Mrs. Torres
did not survive the two-alarm tragedy.
Although covering fires was Weegee's bread
and butter in the 1930s, the experience of
watching these two women struggle between
hysteria and grief, their eyes pleading for
help from firemen, onlookers, and, perhaps
particularly, the photographer, had a lasting
impact. He reproduced the print with the
above title in *Naked City* and wrote about his
sensitivity to such family tragedies in *Weegee
by Weegee*: "Those lousy fire-trap tenements!
The image of the two crying women was to
haunt me the rest of my life. I was raised in a
tenement, and I just couldn't escape them.
The Fire Department used my picture in their
Fire-Prevention Week campaign." The Novem-
ber 27, 1945, issue of *Look* magazine featured
another of Weegee's fire-victim portraits, a
hysterical landlord whose building and store
were in flames.

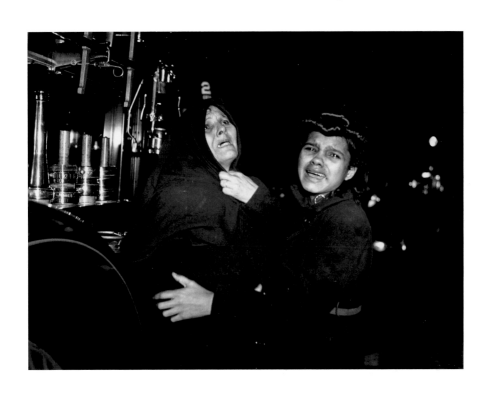

PLATE 5

**Elderly Woman
Rescued from Fire
at 209 W. 62nd St.**

July 20, 1940

Gelatin silver print
34.6 × 21.3 cm
(13⅝ × 8⅜ in.)
Gift of David Raymond
2004.159

PLATE 6

**Fire Alarm / A Couple
Driven Out from
the Burning Tenement**

April 23, 1944

Gelatin silver print
34 × 26.8 cm
(13⅜ × 10%6 in.)
84.XM.190.46

PLATE 7

Bandaged Man

ca. 1940

Gelatin silver print
34.2 × 27.2 cm
(13½ × 10¾ in.)
2000.42.1

In *Naked City*, Weegee included a cropping of this image of an elderly woman (pl. 5) with a caption describing her "slow tortuous journey down the 85 foot aerial rescue ladder. It seems hours up there in the swaying ladder before one actually reaches the street . . . but really it only takes a few minutes." He apparently sold prints of this scene to the *New York Daily News* and again to the magazine *Spot*, which ran it in the October 1941 issue. However, the photographer points out in *Naked City* that his fire pictures were not only destined for the news media but were also useful as evidence "for the detectives and fire marshals who are always on the scene . . . on the look out for pyromaniacs" and to end disputes about who actually made the rescues, since "different firemen will take credit." *PM* ran the image *Fire Alarm* (pl. 6) nearly full

page on April 23, 1944, with details about how the city's Emergency Welfare Division assisted citizens who were burned out of their homes. These facts were combined in the caption with the unusual news commentary, "Weegee calls this his favorite photo."

In plate 7 Weegee presents another type of victim of the city's frequent and dangerous fires. The injured subject, who has received very hasty first aid, is in a soot-covered uniform, suggesting that he is either a fire or police official. Behind him, at right, a young man, also in uniform, anxiously monitors the chaos of the emergency scene. The person assisting at left, in a three-piece suit (an American flag pin on his lapel perhaps indicating a wartime date), does not seem dressed for the crisis but may be one of the fire marshals who would later make use of Weegee's pictures.

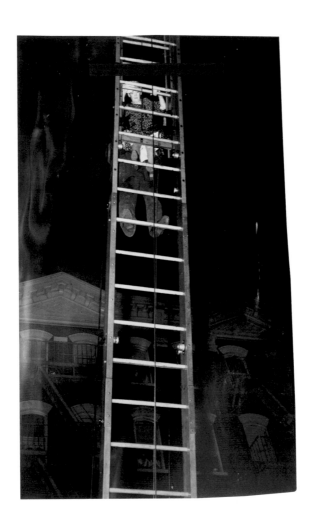

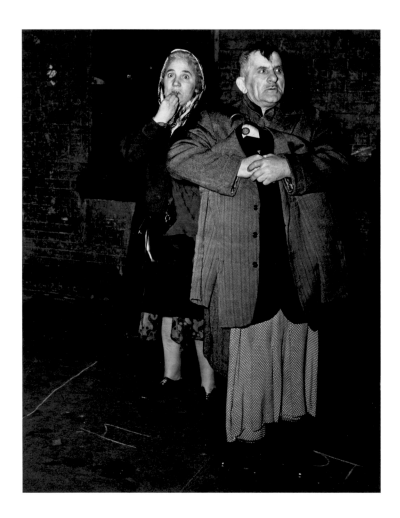

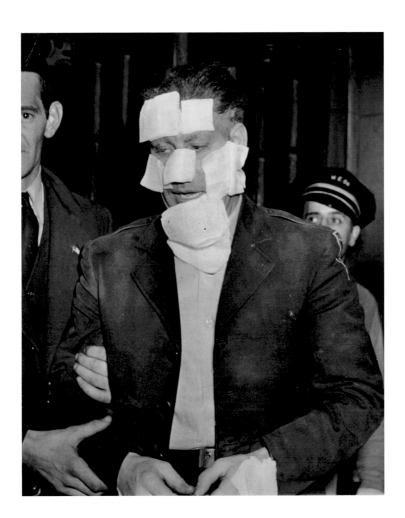

PLATE 8

Their First Murder

ca. 1950 gelatin silver print
from an October 9, 1941,
negative
25.7 × 27.9 cm
(10⅛ × 11 in.)
86.XM.4.6

PM, for which the always-independent Weegee operated as an unofficial police photographer, published this picture on October 9, 1941, with the headline "Brooklyn School Children See Gambler Murdered in Street." The caption for this image of the crowd of spectators as well as for the photograph below it, of the victim, reports the facts of this daytime crime: "Pupils were just leaving P.S. 143, in the Williamsburg section of Brooklyn, at 3:15 yesterday when Peter Mancuso, 22, described by police as a small-time gambler, pulled up in a 1931 Ford at a traffic light a block from the school. Up to the car stepped a waiting gunman, who fired twice and escaped through the throng of children. . . . The older woman is Mancuso's aunt, who lives in the neighborhood, and the boy tugging at the hair of the girl in front of him is her son, hurrying her away." A good example of how flash changes the scene, casting the background into generalized darkness, the picture was used by Weegee to illustrate "How to Catch 'The Drama of Life' in News Photography" in *Weegee's Secrets of Shooting with Photoflash*. He also published this image in *Naked City* but did not give it the satirical title *Their First Murder* until it appeared in *Weegee by Weegee*. By then, he was freely indulging his interest in caricature, allowing himself to be as sharply critical of twentieth-century New York life as the political cartoonist Honoré Daumier (1808–1879) had been of nineteenth-century Parisian society.

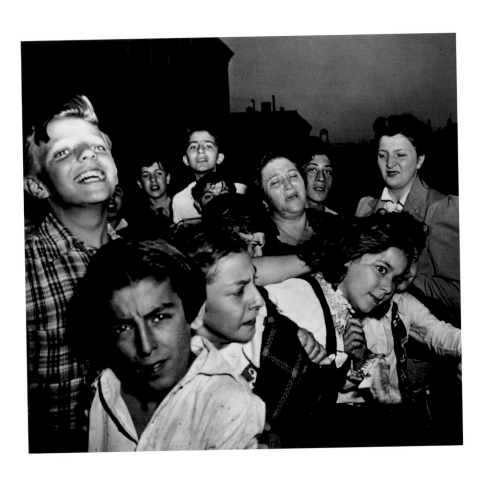

PLATE 9

Off Duty Cop Does Duty, Kills Gunman Who Tries Stickup

ca. 1950 gelatin silver print
from a February 3, 1942,
negative
34 × 26.8 cm
(13⅜ × 10%⁄₁₆ in.)
84.XM.190.12

The editors of the adventurous *PM* knew
the importance of visual imagery enhanced
by good layout. An entire page of the Febru-
ary 3, 1942, issue was devoted to Weegee's
pictures of the violent death of the gang-
ster Andrew Izzo. This image, cropped hori-
zontally around the corpse in a tomblike
manner, dominated the top two-thirds
of the page. Below, a close-up of the shooter,
patrolman Eligio Sarro, enjoying a cigarette,
appeared at right with a back view of Izzo's
body at left. Caption text was given only the
small space between the pictures and read
like fiction: "The boys were playing a little
pool and cards in the Spring Arrow Social
and Athletic Club, 344 Broome St., near the
Bowery last night. Patrolman Eligio Sarro,
off duty, went in for a pack of cigarets. Four
men entered. 'This is a stick up [*sic*],' the
leader muttered. Sarro was a little slow
getting his hands out of his overcoat pockets.
'Get 'em up,' ordered the leader. Sarro did.
One hand held a gun. When he got through
firing, the leader was dead."

Weegee was known for illustrating
such stories. After the release of *Naked City*,
he was in demand as a teacher as well as
a photographer. In August 1946 *Life* covered
his work at a seminar in Chicago, where,
in a class on spot-news photography, he
employed a well-dressed dummy, a plastic
revolver, and his own gray fedora to instruct
students in how to photograph a corpse.

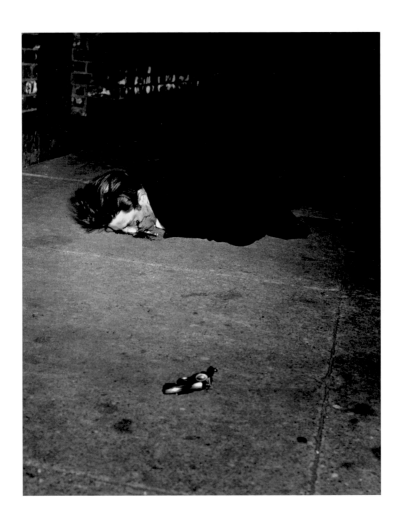

PLATE 10

Crime and
Punishment

ca. 1950 gelatin silver print
from a November 24, 1941,
negative
33.7 × 26.2 cm
(13 ¼ × 10 ⁵⁄₁₆ in.)
84.XM.190.32

True to his reputation for getting to the
scene almost as an event occurred, Weegee
arrived to photograph the key elements
of this incident minutes after it happened.
PM, on November 24, 1941, ran this image
nearly full page above the headline "Cop
Kills Holdup Man." Unlike newspapers
of the twenty-first century, *PM* wasn't shy in
publishing the picture of the policeman
who did the shooting. As *PM* reports: "A
few minutes after he had held up an Essex
Street lunchroom on the Lower East Side
and shot a patron, Vincent Mannuzza,
31, was lying dead at the feet of the cop
who shot him. Patrolman Laurence Cramer,
right, shot and killed Mannuzza after a
two-block chase and is shown handing the
gunman's revolver to Sgt. Eugene Morland.
The $20 loot taken from the restaurant lies

in Mannuzza's hat at his side. An ambulance
surgeon crouches over the dead man who
was shot in the head and back."

In printing images of the dead, con-
temporary newspapers sometimes made a
distinction between the corpses of crimi-
nals and their victims. In *Life* magazine's
first article about Weegee in April 1937,
his picture of a crime scene where a body
was found in a trunk is reproduced with
and without the remains, the latter being the
way the *New York Post* chose to run it.
Distorting the "reality" of that news photo-
graph even further is Weegee's inclusion of
himself as a detective inspecting the scene.

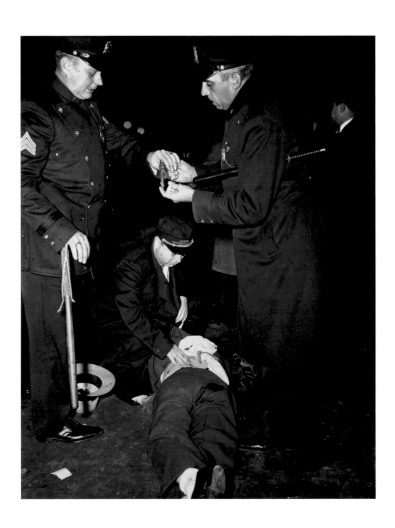

PLATE II

**Transvestite /
The Gay Deceiver**

ca. 1950 gelatin silver print
from a ca. 1939 negative
33.3 × 26 cm
(13⅛ × 10¼ in.)
86.XM.4.3

Weegee was very familiar with the paddy
wagons, or Black Marias, that brought sus-
pects picked up during the night to Man-
hattan police headquarters to be booked
for major and minor crimes. He lived in a
one-room office-apartment (see p. 9) at
5 Center Market Place, just opposite the
headquarters. In *Naked City* he referred to
"the night's 'catch' of persons" to be "finger-
printed, 'mugged,' . . . and then paraded
in the police line-up . . . where they are
questioned by police officials on a platform
with a strong light on their faces." With
or without their cooperation, Weegee would
frame these recently arrested subjects as
the vans' cagelike doors opened and the
suspects descended. Most were not as happy
about having their portrait made under
these circumstances as this fellow, who
responds to Weegee's camera with
a big smile and the lifting of his dress.
He and others apprehended at a dance "for
dressing as girls" concluded the *Naked
City* section Weegee called "'Pie' Wagon."

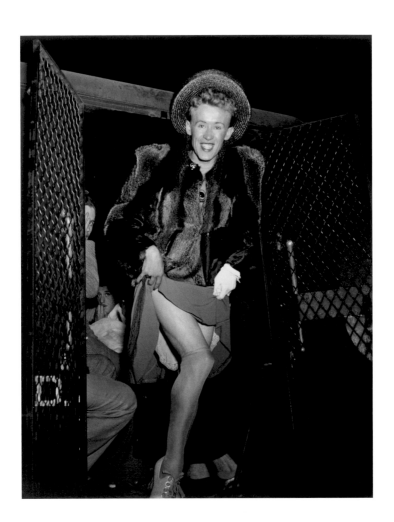

PLATE 12

Frank Pape, Arrested
for Homicide

November 10, 1944

Gelatin silver print
27 × 33.8 cm
(10⅝ × 13⁵⁄₁₆ in.)
84.XM.190.37

On November 10, 1944, *PM* published a cropped state of this image with an article headlined "Youth in Drach Case Is Placed in Bellevue." A compact square portrait of the confessed killer, Weegee's picture is captioned: "Frank Pape, 16, a freshman at Bronx Vocational High School, is under arrest on a homicide charge. Police say he confessed tying up William Drach, 4, on Oct. 29, in the basement of 825 Eagle Ave., Bronx, after having seen it done in a movie. William strangled to death. The solution exonerates William's 8-year-old brother, Robert." Known in his Bronx neighborhood, where his father was the superintendent at 815 Eagle Avenue, as a good boy who would share his earnings as a butcher with other kids, Pape told police "an urge over-took him" while he and Drach were playing "tie-up."

Pape's own juvenile status is accentuated in this wider view of the back of the paddy wagon. Wearing a schoolboy's cap and jacket, he shrinks into a far corner. His companions are well-dressed adult males in overcoats and pin-striped trousers, possibly much more experienced criminals with lawyers waiting to bail them out. Weegee focuses sharply on the youngster's solemn face, putting him well behind the broad expanse and magnified strength of the wagon's cage. With his lens right next to the confining wires, the photographer frames the boy as a captive animal, still available for public consumption, but locked up, in the system, and beyond help.

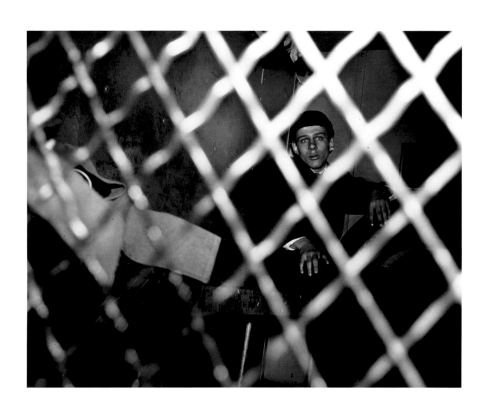

PLATE 13

Cop Killer

ca. 1950 gelatin silver print
from a January 16, 1941,
negative
33.7 × 26.8 cm
(13¼ × 10⁹⁄₁₆ in.)
84.XM.190.30

PLATE 14

Waiting in Line for
the Night Judge

ca. 1950 gelatin silver print
from a pre-1946 negative
26.8 × 33.8 cm
(10⁹⁄₁₆ × 13⁵⁄₁₆ in.)
84.XM.190.26

PLATE 15

Arrested for Bribing
Basketball Players

ca. 1950 gelatin silver print
from a January 25, 1945,
negative
30.7 × 26 cm
(12⅛ × 10¼ in.)
84.XM.190.36

Weegee began his police-beat photography during the Depression years, when crime was considered by some to be not only a viable job but also a glamorous one. The newspaper columnist Damon Runyon (1884–1946) wrote humorous New York stories about "guys and dolls," mostly small-time gangsters and their girlfriends, for whom gambling, stealing, and prostitution paid the rent. In the immensely popular gangster movies of the 1930s, Hollywood was accused of distorting the lives of these "desperate characters of the underworld," as Runyon called them in "Tobias the Terrible" (1932). Knowing that small-town America had begun to idolize the outlaw, Runyon has an insecure young man, recently arrived in the big city, say of his girl in that story: "She wishes to know why I cannot be a big gunman and go around plugging people here and there and talking up to politicians and policemen, and maybe looking picturesque and romantic like Edward G. Robinson or James Cagney." The novels of

Raymond Chandler (1888–1959) and Dashiell Hammett (1894–1961), like the comic strip *Dick Tracy*, bolstered interest in the cops and detectives who dealt with these dangerous heroes. By association, the crime photographer became part of this alluring world, as seen in plate 14. As Weegee shows, he and his professional colleagues got as close to these "desperate characters" as anyone.

The man being photographed during booking by the police in plate 13 is Anthony Esposito, an accused murderer described by Weegee in the January 16, 1941, issue of *PM* as a "sullen, surly, snarling animal." The newspaper's January 31, 1945, edition described the two men shielding themselves in plate 15 as "Henry Rosen (left) and Harvey Stemmer, alleged fixers in the Brooklyn College basketball scandal." In *Naked City* Weegee writes of how "the ones that 'cover' up their faces are the Fences . . . Fagins and jewel thieves . . . who start crying and pleading with me not to take their picture."

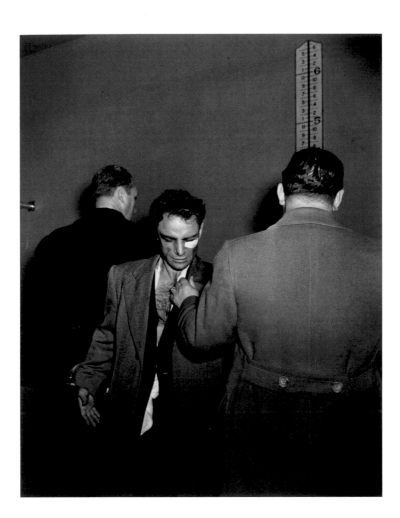

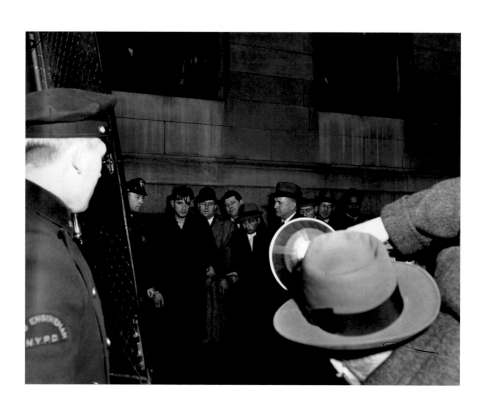

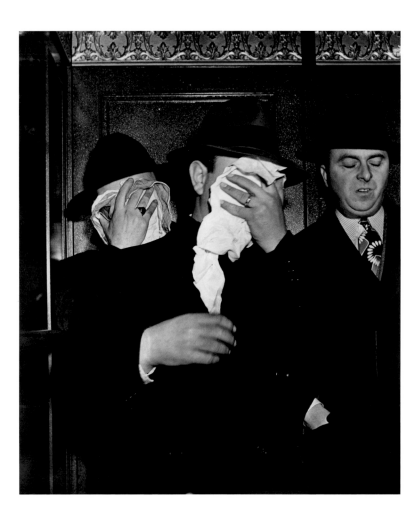

PLATE 16

Sudden Death for One, Sudden Shock for the Other / Mrs. Dorothy Reportella, Accused of Hitting Bread Truck with Her Car

ca. 1950 gelatin silver print
from a September 7, 1944,
negative
27.1 × 34.1 cm
(10 11/16 × 13 7/16 in.)
84.XM.862.2

Published in *PM* on September 7, 1944, a cropping of this photograph of Mrs. Dorothy Reportella appeared opposite another Weegee picture from the accident scene, that of Rudolph Supik, driver of a bakery truck, dead on the pavement among the loaves and rolls he was carrying. The paper's layout for this tragic story also contained an image of Mrs. Vanta Supik, wife of the victim, who "was summoned to the scene of the accident to identify the body. She took one look, and became hysterical." Mrs. Supik quickly grasped the meaning of the horrific view, which included police officers, firemen, a minister giving last rites, and Lower East Side onlookers gathered at First Avenue and Seventh Street. For Mrs. Reportella, identified as twenty-eight years old and residing at 36 Linden Street, Brooklyn, reacting to the accident was a more complicated process. The policeman shown at left seems to be trying to communicate with her, but her expression reflects the paralysis of shock. In fact, one might say that Weegee's flash photograph, made in the dark of dawn, extended the driver's sense of confusion and immobility so that *PM*'s readers could share it later the same day. The "A" window sticker represents the driver's wartime gas ration status, but in this composition it seems to prompt a narrative that could include accident, alarm, amazement, anxiety, and arrest.

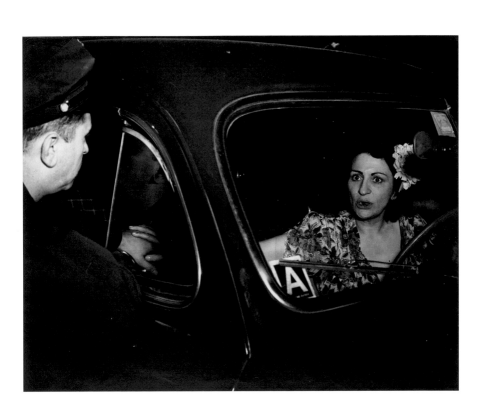

PLATE 17

Mother and Child
in Harlem /
Mrs. Bernice Lythcott
and Son Leonard

ca. 1950 gelatin silver print
from an October 18, 1943,
negative
33.7 × 26.7 cm
(13¼ × 10½ in.)
87.XM.65.1

In August 1943 Harlem experienced a race riot after news spread that a white police officer had shot a black soldier at 8th Avenue and 126th Street. Mayor Fiorello La Guardia (1882–1947) called in federal troops as well as thousands of policemen and deputized volunteers to maintain order. World War II was exacerbating U.S. racial tensions. Weegee photographed the riot, and that fall, *PM* asked him to cover another violent incident at an apartment house in Harlem. The article that ran with three "Photos by Weegee" on October 18 was headed "Police Called to Give Negroes 'Freedom From Fear'" and began, "Acts of vandalism directed against a 166th St. apartment house recently opened to Negro tenants died down Saturday night after a week of disorder evidently intended as a warning to Negro families not to move into the block." The tightly cropped, and no doubt posed, image of Mrs. Lythcott holding her son behind the shattered door pane appeared with a caption calling the picture "a symbol of that evil thing, race hatred." The entire Lythcott family was presented in another photograph. Mr. Lythcott, who had a brother and two brothers-in-law in the service, referred to his white neighbors in this Harlem boundary area, saying, "I think it's very foolish for them to act this way with a war going on."

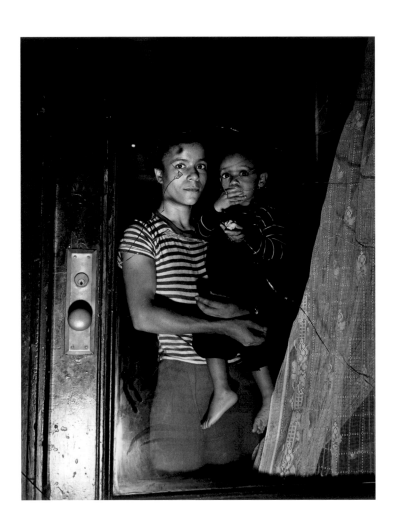

PLATE 18

U.S. Hotel at
263 Bowery

ca. 1950 gelatin silver print
from a ca. 1944 negative
33.3 × 27.3 cm
(13⅛ × 10¾ in.)
84.XM.190.14

The *WPA Guide to New York City* (1939),
compiled by unemployed writers during
the Depression, described the neighborhood
along lower Fourth Avenue this way: "The
Bowery today is chiefly given over to pawn-
shops, restaurant equipment houses, beer
saloons, and miscellaneous small retail
shops. Here flophouses offer a bug-infested
bed in an unventilated pigeonhole for twenty-
five cents a night. . . . Thousands of the
nation's unemployed drift to this section and
may be seen sleeping in all-night restaurants,
in doorways, and on loading platforms."
Weegee was a habitual visitor to this area
between the Jewish Quarter and Little
Italy, first as a barely employed young man
looking for temporary shelter and then
as a photographer following the police radio
or looking for human-interest subjects.

"A Place to Sleep," the fifth section
of *Weegee's People*, the artist's second book
about New York, contains this self-titled
image from the Bowery. The hallway
mirrors at the bottom of the stairway are
cropped out, eliminating any distraction
from the central stack—the visual ladder—
of words. The graphic power of this dimin-
ishing pile of letters no doubt attracted
Weegee's eye, and the irony of the U.S. as
flophouse is something this immigrant
would not have missed.

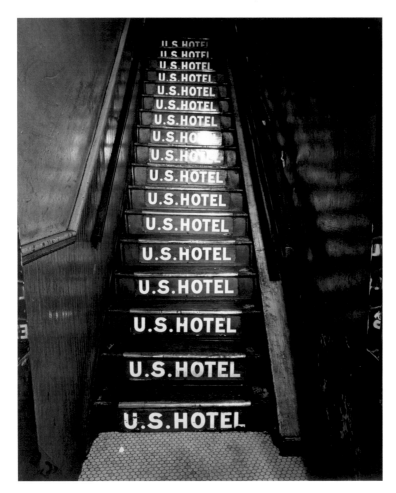

PLATE 19

A Stitch in Time

ca. 1950 gelatin silver print
from a June 9, 1941, negative
26.7 × 34.4 cm
(10½ × 13⁹⁄₁₆ in.)
84.XM.190.15

Weegee sometimes provided the words as well as the pictures for stories in *PM*. "Coney Island Revisited," published on June 9, 1941, was such a case, and this comical beach image was included with the caption: "First aid for ripped slacks. I don't know how Mama happened to bring along her needle and thread, but I didn't pose the picture. You don't have to do that to get amusing pictures at Coney. I go out every summer to photograph the crowds. They're always the same—and always different. One difference from 1940 and yesterday was the number of soldiers in uniform on boardwalk, looking over the gals on sand below." Interestingly, this Coney Island composition was later the centerpiece for a *Look* magazine spread of ten pictures accompanying a wartime piece asking the question "Who Should Wear the Pants?" Running on August 25, 1943, next to a plea for blood needed by the Red Cross War Fund and an ad promoting Lipton Tea as the drink of doughboys, this article no doubt had implications beyond fashion, but its text stuck to the protocol of coping with the current trend: "Women, from the sidewalks of New York to the classrooms of California, are wearing pants (slacks, they call them). . . . The trouble, says etiquette expert Emily Post, is that ladylike curves can't be squeezed into pants designed for a man."

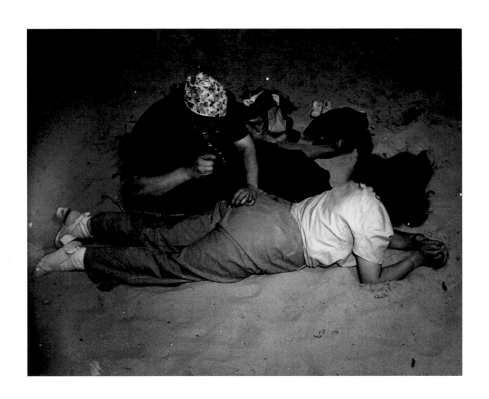

PLATE 20

PLATE 21

PLATE 22

Tenement Sleeping

ca. 1950 gelatin silver print
from a June 1943 negative
32.9 × 26.7 cm
(12¹⁵⁄₁₆ × 10½ in.)
84.XM.190.7

Sleeper in a Bar

ca. 1950 gelatin silver print
from a 1939 negative
33.7 × 26.4 cm
(13¼ × 10⅜ in.)
87.XM.65.2

Tired Business Man at the Circus, Madison Square Garden

ca. 1950 gelatin silver print
from a June 28, 1943, negative
26 × 34.4 cm
(10¼ × 13⁹⁄₁₆ in.)
84.XM.190.20

Some of the tough bachelor characters in Damon Runyon's New York stories of the 1930s and 1940s received monikers related to their after-dark habits. For example, an assassin who is known as a genius at "taking care of anybody that somebody wishes taken care of" is called Asleep ("Situation Wanted," 1936), and a man who helps Sorrowful the bookie care for an abandoned little girl is named Sleep-out ("Little Miss Marker," 1932). Like Runyon, Weegee was happy to turn the spotlight on the outlaw element that kept the city awake at night. He also photographed people at rest, commenting in *Naked City*, "Sunday is a good day for sleeping—so is any other day—when one is tired."

The "A Place to Sleep" section of *Weegee's People* contains images primarily of flophouse signs and facades and homeless individuals slumbering in impromptu beds of cast-off cardboard. As a sometimes unemployed or poorly paid young man, Weegee, too, had experienced cheap Bowery hotels,

as well as park benches and fire escapes, as places to find sleep. In fact, a photograph of Weegee, unshaven and napping on a bench, is the book's introductory image. He claims it was not posed, but taken by a passing "girl photographer" who later mailed the film to him. Be that as it may, the author-artist, who worked most nights, spent a lot of time thinking about sleep and was comfortable with the idea that it sometimes had to be done in public.

A fire escape—narrow, exposed, and uncomfortable though it may be—provides a cooler place to rest for the New Yorker found and photographed, but not awakened, by Weegee one hot summer night (pl. 20). Tired, and probably intoxicated, the man dozing in a bar (pl. 21) is also unaware of the activity around him. In a third picture on the subject of sleep (pl. 22), infrared film appears to have been Weegee's mode of catching an exhausted beer barker snoozing on the job at the circus.

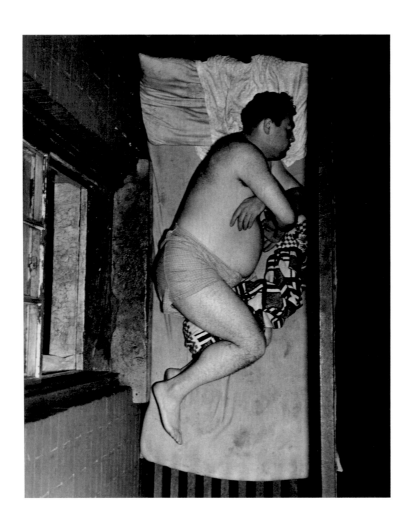

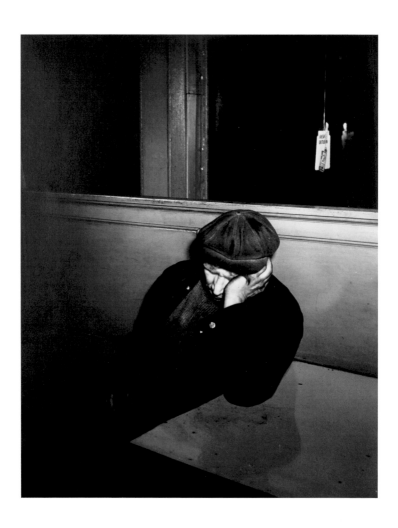

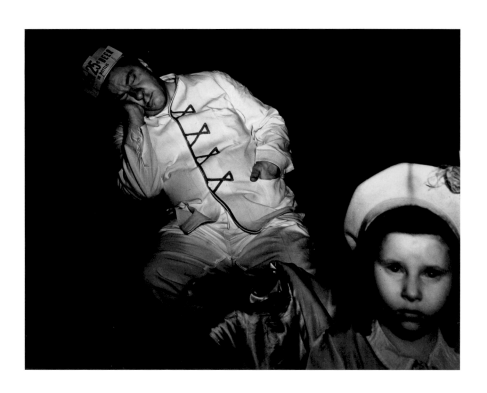

PLATE 23

Circus Zebras, Madison Square Garden (Mama Mabel and Her First-Born)

ca. 1950 gelatin silver print
from an April 21, 1941, negative
32.9 × 26.5 cm
(12 $^{15}/_{16}$ × 10 $^{7}/_{16}$ in.)
84.XM.190.28

The main characters of Damon Runyon's 1930 story "The Hottest Guy in the World" are a well-armed gangster—Big Jule—and an escaped circus gorilla—Bongo. Before chaos erupts with Bongo's kidnapping of a baby, the story's hospitable narrator invites Big Jule into his apartment and offers him "a chair by the window where he can see the citizens walking to and fro down in Eighth Avenue and watch the circus wagons moving into Madison Square Garden by way of the Forty-ninth Street side, for the circus always shows in the Garden in the spring before going out on the road." The Ringling Bros. and Barnum & Bailey Circus, formed after the Ringling brothers merged their circus with "The Greatest Show on Earth" in 1919, started out each spring in New York with great fanfare. Weegee enjoyed covering the circus's annual visit; however, this Sunday call on the new addition to the zebra family was a special request from the circus publicity department. The press agents knew the unusual birth announcement would make good advertising. Another Weegee view of the baby feeding next to its mother ran in *PM* on April 21, 1941, under the headline "It's a Boy? . . . 20 Pounds."

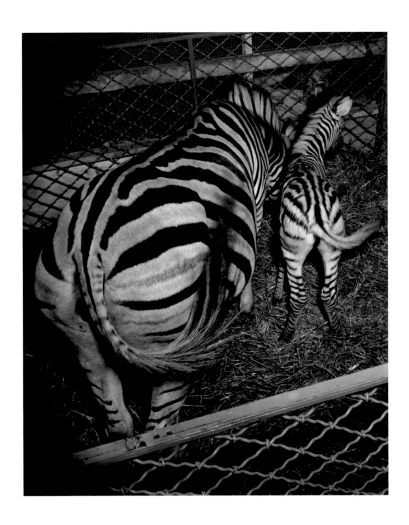

PLATE 24

Emmett Kelly, Ringling Bros. and Barnum & Bailey Circus

ca. 1950 gelatin silver print
from a May 1943 negative
26 × 34.4 cm
(10¼ × 13⁹⁄₁₆ in.)
84.XM.190.5

Weary Willie, the unhappy, unshaven tramp with the big nose who inspired many imitators, like Red Skelton's Freddie the Freeloader, was the stage persona of Emmett Kelly (1898–1979). A Kansas native, Kelly first performed his hobo act in 1933. He subsequently traveled with the Ringling Bros. and Barnum & Bailey Circus in the 1940s and 1950s, copyrighted his makeup, and enjoyed his own dressing room when the circus played Madison Square Garden. Weegee may have become well acquainted with Kelly during the circus's annual stints in New York. Here, clown and photographer are working together to create a performance portrait; Kelly tips his hat to Weegee, who tilts his camera. In the background, most of the audience is following another act, but one couple, looking very

conventional next to the made-up clown, is caught watching Weegee. It isn't known whether he was in disguise on this occasion; however, the same year he did assume a clown costume while covering the Ringling Bros. "Spangles" circus "from the inside." "I decided to make my camera so obvious that the spectators wouldn't believe they were being photographed," he reported in *PM* on July 9, 1943. He was dressed and coached by the clown Roy Barrett before entering the ring with his fellow jesters. The laughing crowd, thinking he was a buffoon and his camera a prop, responded with the spontaneity he wanted.

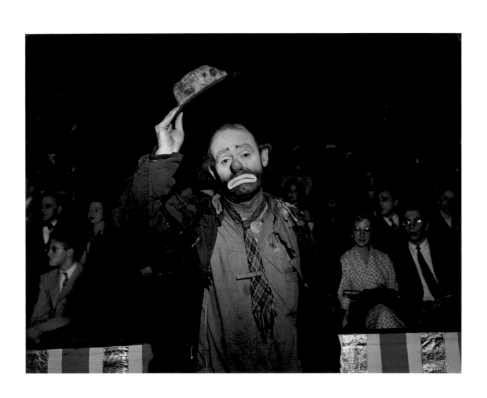

PLATE 25

**Mrs. George
Washington Cavanagh
[sic] / The Critic**
November 22, 1943

Gelatin silver print
Image: 25.7 × 32.9 cm
(10⅛ × 12¹⁵⁄₁₆ in.)
Sheet: 27.9 × 35.2 cm
(11 × 13⅞ in.)
84.XP.459.11

PLATE 26

**Intermission /
First-Nighters
at the Met**
November 1943

Gelatin silver print
26.7 × 34 cm
(10½ × 13⅜ in.)
84.XM.190.38

PLATE 27

**The Body Beautiful /
Celebrating**
November 1943

Gelatin silver print
26.7 × 27.1 cm
(10½ × 10¹¹⁄₁₆ in.)
86.XM.4.5

The beginning of the new opera season was a New York ritual Weegee routinely covered for the papers. On December 3, 1940, *PM* ran several of his opening night images along with the photographer's account in words: "Last night, at the opening of the Metropolitan Opera season, I rubbed elbows and stepped on the toes of the society crowd (and I don't mean cafe society). On the outside of the opera house on W. 39th St., after the performance, between the mink coats and the high hats, I felt like an Italian in Greek territory. Without a high hat the cops showed you across the street. They gave me dirty looks but I was saved by my press card." A candid picture of Weegee with his signature felt hat and cigar accompanied the above, emphasizing the irony of his commenting on the subject. The opera job in particular provided rich material for Weegee's satirical bent. Several seasons later, armed with infrared film as well as flash-bulbs, he created a sardonic series on the behavior of operagoers.

Infrared film, which Weegee used mainly for the purpose of photographing in the dark without a flash, so as to avoid annoying or alerting his subjects to his presence, allowed him to literally get under the skin of New York high society. It revealed veins, whiskers, and other natural, but unsightly, human characteristics. Men in tuxedos, for example, might look unshaven, even unhealthy (see pl. 26), and women in evening dresses looked even more exposed (see pl. 27).

The Critic (pl. 25), presenting Mrs. George W. Kavanaugh, her friend Lady Decies, and a recruit from a Bowery bar, became one of the photographer's best-known works. *Life* used a cropping that eliminated the "plain people" at left, probably waiting in line for standing room tickets, in its November 22, 1943, coverage of the fall Met opening. In *Naked City*, Weegee writes about the image that "I couldn't see what I was snapping but could almost smell the smugness."

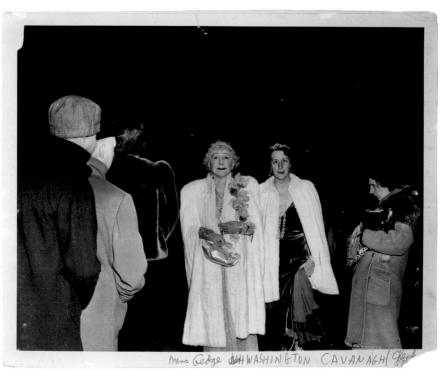

Mrs George H WASHINGTON CAVANAGH

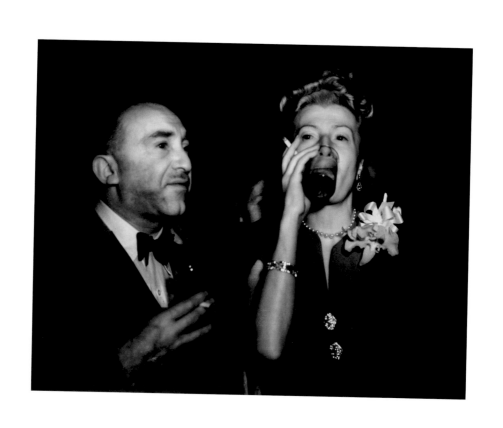

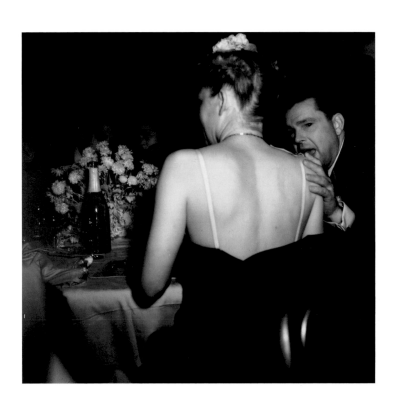

PLATE 28

PLATE 29

PLATE 30

Couple Kissing in a Bar

ca. 1950 gelatin silver print
from a ca. 1942 negative
33.3 × 26.7 cm
(13⅛ × 10½ in.)
84.XM.862.4

Bar in Greenwich Village

ca. 1950 gelatin silver print
from a ca. 1937 negative
25.6 × 33.5 cm
(10¹⁄₁₆ × 13³⁄₁₆ in.)
84.XP.926.2

Audience in the Palace Theater

ca. 1953

Gelatin silver print
26.2 × 33.7 cm
(10⁵⁄₁₆ × 13¼ in.)
84.XM.4.10

Weegee never let an embrace escape his camera. At least that would appear to be the case based on the enormous number of kissing couples on deposit in the International Center of Photography archive and the frequency with which they surface in publications of Weegee's work, from a section in *Naked City* called "Lovemaking on the Beach" to the posthumous book *The Village* (1989). Weegee's contemporary, the Parisian night-life photographer Brassaï (1899–1984), also found many uninhibited subjects for his camera; he wrote in *The Secret Paris of the 30's* (1976) that the city had always favored lovers: "Couples kiss on public benches, in the subway, under streetlights, and nobody is shocked, no one pays any attention." While the young lovers of Greenwich Village were probably indifferent to Weegee's camera, in other parts of town he would employ a triangular prism lens attachment to "see around corners"

when he wanted to shoot "people doing things they never would do if they thought I was watching them" (*Weegee's Creative Camera*, 1959).

In a March 18, 1947, *Look* article on the "State of the Nation," Weegee's picture from a Greenwich Village bar (pl. 29) is cropped and captioned, "Our morals present a sordid picture." A report on increasing rates of divorce, excessive drinking, sexual offenses, and juvenile delinquency follows this commentary on the image: "This picture of a young couple in a drunken embrace will shock many people." *Look* may not have represented the average citizen of New York, but it did reflect a generally conservative U.S. opinion. For Weegee, however, his "best seller, year in and year out," as he wrote in *Weegee's Creative Camera*, was "couples making love," whether at a bar (pl. 28) or in a movie theater (pl. 30).

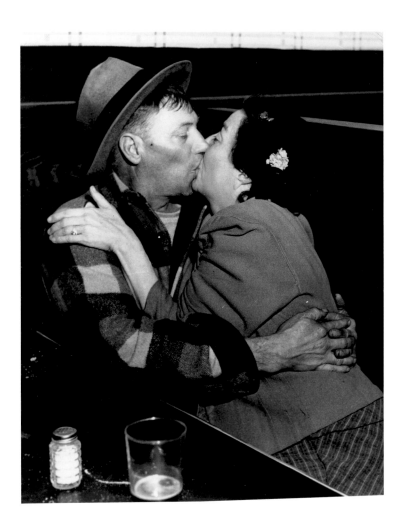

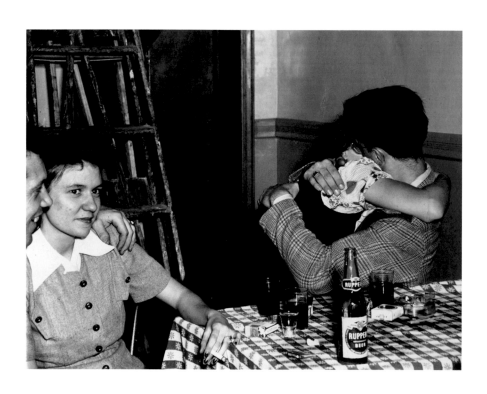

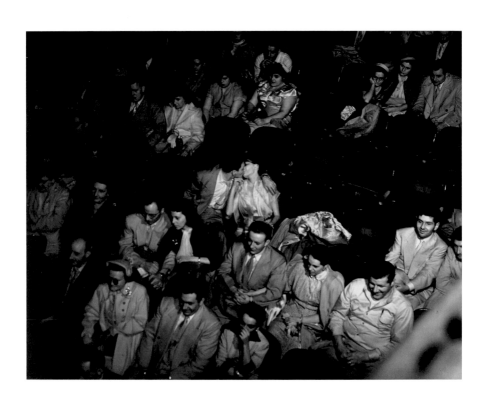

PLATE 31

At the Palace Theater

ca. 1950 gelatin silver print
from a 1943 negative
26.4 × 34 cm
(10⅜ × 13⅜ in.)
86.XM.4.11

Weegee's People contains seventeen portraits of children, made as they sat entranced in a Saturday matinee at Loew's Commodore Theater. The photographer titled this section "The Children's Hour" and observed, "I took the pictures in the dark with infra-red rays so that I wouldn't disturb anyone." This similar image was made at the Palace Theater. Previously a prominent vaudeville house featuring performers such as Sophie Tucker and Pat Rooney, the Palace, opened in 1913 at Broadway and Forty-seventh Street, was competing as a venue for motion pictures by the late 1930s. Fueling the trend for luxurious movie theaters, the Paramount on Broadway went up in 1926, boasting an auditorium of thirty-six hundred seats and a ten-story ceiling; the elegant Seventh Avenue Roxy followed in 1927 with a large orchestra pit and space to accommodate sixty-two hundred guests. That same year, a new sound system made the film *The Jazz Singer* a success. Movie studios raced to produce "talkies," showmen rushed to build palatial theaters, and the city's children, particularly those living in tough circumstances, flocked to the fantasies offered by both. Weegee, a former silent film fiddle player, now recorded audience reaction rather than manipulating it.

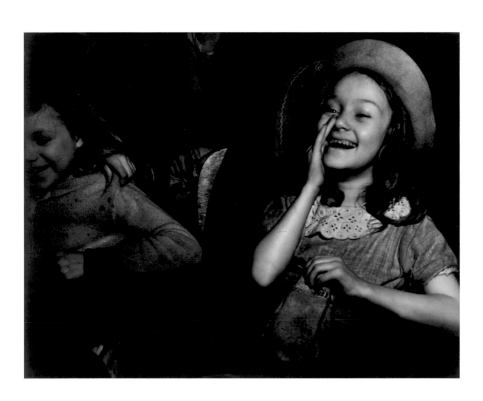

PLATE 32

**Easter Sunday
in Harlem**

PLATE 33

Love in Harlem

Before 1946

PLATE 34

**At the Concert
in Harlem**

ca. 1950 gelatin silver print
from a 1940 negative
34.5 × 27 cm
(13⅝ × 10⅝ in.)
84.XM.190.8

Gelatin silver print
34.1 × 27 cm
(13⁷⁄₁₆ × 10⅝ in.)
86.XM.4.1

ca. 1950 gelatin silver print
from a pre-1946 negative
34.1 × 27.1 cm
(13⁷⁄₁₆ × 10¹¹⁄₁₆ in.)
86.XM.4.8

Negro Harlem, along with the Bowery, Greenwich Village, and Times Square, was a favorite haunt for Weegee. Its conviviality probably attracted his eye; he was always looking for the public face of groups as well as individuals. Although it might seem unlikely that he would be prowling for pictures on Easter morning, he says in *Naked City* that he "spotted this happy man [pl. 32] coming out of church . . . he told me that he was a clothing salesman . . . and that every Easter Sunday he put on his full dress suit." When the photographer compiled his next book, *Weegee's People*, he concentrated on the social life of New Yorkers. The book's extensive "Saturday Night" section contains images of dancers, performers, and partygoers enjoying themselves in nightclubs, bars, and dance halls. Weegee chose many Harlem images, including plates 33 and 34, the latter cropped more tightly around the figure of the mooning young woman. Perhaps made at the Savoy Ballroom on Lenox Avenue, a popular venue for musicians like Duke Ellington, or the Apollo Theater on 125th Street, a great success with black and white audiences since its opening in 1934, these two compositions display Weegee's trademark use of the unconscious gesture. They also highlight his less-obvious sensitivity to contemporary fashion trends.

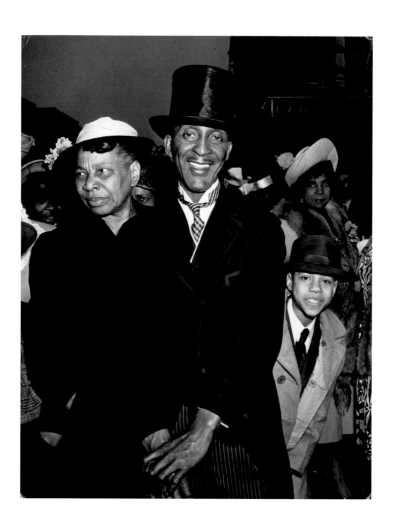

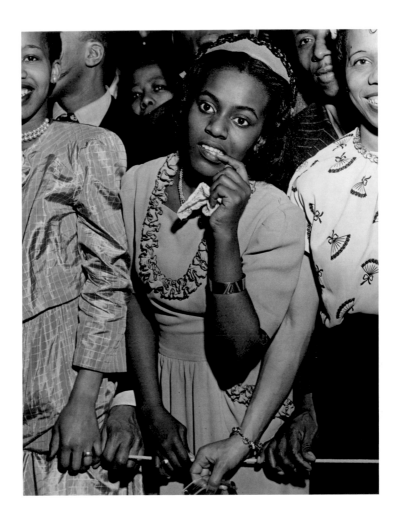

PLATE 35

**Jitterbugs, Who
Jumped on Stage,
While Harry James'
Orchestra Was
Playing at Paramount
Theater**
April 1943

Gelatin silver print
34.1 × 27.1 cm
(13⁷⁄₁₆ × 10¹¹⁄₁₆ in.)
2003.99.6

Not to be thought less hip than the teenagers they were writing about, the journalists who penned two spring 1943 articles that featured this picture entitled their pieces "Hepcats Swamp Movie Palaces, Where Jive is King, Thing" (*PM*, April 29, 1943) and "Jitterbugs Jam James's Jive Jag" (*Life*, May 10, 1943). Both articles used multiple audience images with emphasis on the enthusiastic "girl-cats," but Weegee's photograph of this dancing couple (in a wider version, with the big band more evident in the background) was also given a lot of space. *Life* called the two subjects "runaway cats," because they not only jumped out of their seats but also jumped onto the stage with trumpeter Harry James (1916–1983), rather than dancing in the aisles. Weegee's unruly pair seemed to embody what *PM* called the "current teen-age craze for jive-bombing orchestras" since they had "eluded ushers to leap to the Paramount stage and go into their jitterbug routine while James was playing *Two O'Clock Jump*, hepcat favorite." The press could hardly avoid turning this "war phenomenon" into news: the *New York Times* offices were located next to the Paramount Theater, so the long, daytime ticket lines aroused reporters' curiosity. Weegee's camera, however, always had the pulse of Times Square at night.

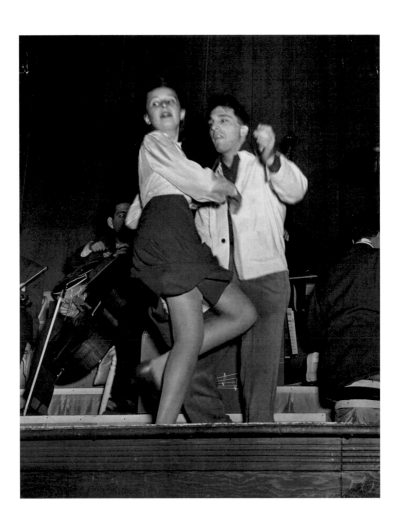

PLATE 36

**Billie Dauscha and
Mabel Sidney,
Bowery Entertainers**

ca. 1950 gelatin silver print
from a December 1944
negative
33.3 × 26.8 cm
(13⅛ × 10 9⁄16 in.)
84.XM.190.34

PLATE 37

Songstress at Sammy's

April 16, 1944

Gelatin silver print
34.5 × 26.9 cm
(13⅝ × 10⅝ in.)
2003.99.9

PLATE 38

Portrait of a Lady

December 1944

Gelatin silver print
Image: 28.4 × 13 cm
(11 3⁄16 × 5⅛ in.)
Mount: 47.8 × 36.4 cm
(18 13⁄16 × 14 5⁄16 in.)
84.XP.453.2

Sammy Fuchs (1884–1969), founder of Sammy's on the Bowery, died just months after his friend Weegee. Fuchs grew up in the Bowery and was a student of the local jargon. After years as a busboy, waiter, and restaurant manager, he opened his saloon at 267 Bowery in 1934. Apparently at the suggestion of a visiting Englishman, Fuchs decided to expand his business in the 1940s by offering entertainment as well as drink. He obtained a cabaret license and installed an orchestra. Performers included Billie Dauscha and Mabel Sidney (pl. 36); Norma Devine, Daisy Lewis, and Tilly Schneider; and Dora (pl. 37), "a singer of sentimental songs," according to Weegee in the April 16, 1944, *PM*. Customers of all types, from uptown swells to flophouse residents, flocked to Sammy's as it gained a reputation for being what the photographer called in *Naked City* "the poor man's Stork Club," an alternative to that highbrow nightclub. He devoted a section titled "The Bowery" to Sammy's in the book; Sammy, in turn, hosted its publication party. The raucous festivities for more than two hundred were covered by *PM* on July 19, 1945, where, under an image of Weegee on the dance floor, it was reported that "full bottles of scotch and rye and heaping platters of corned beef and pastrami and pickles and potato salad were set on the tables, and some old women in Gay Nineties costumes danced obscenely and screeched into an ear-splitting public address system for the delectation of Weegee guests." Weegee's cropping of plate 36 (pl. 38) emphasizes the bawdy atmosphere at Sammy's.

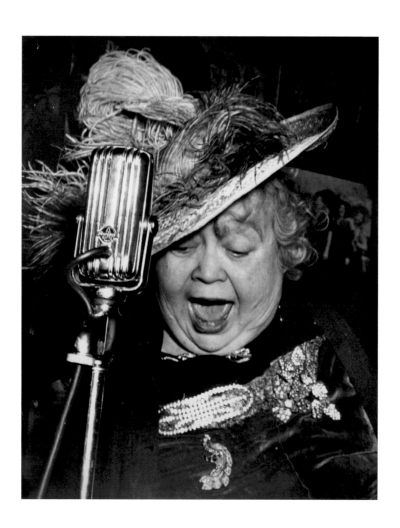

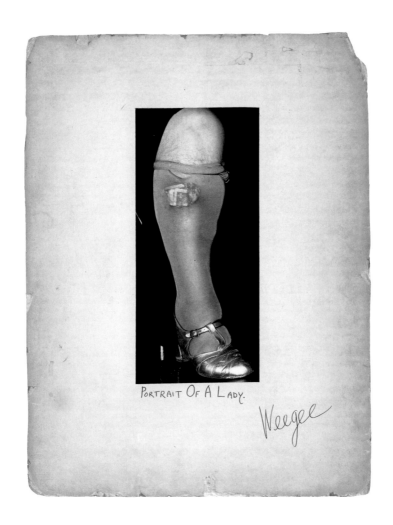

PORTRAIT OF A LADY.

Weegee

PLATE 39

Shorty, the Bowery Cherub

ca. 1950 gelatin silver print
from a December 31, 1942,
negative
35.1 × 26.5 cm
(13¹³⁄₁₆ × 10⁷⁄₁₆ in.)
84.XM.190.23

Shorty was probably a regular at Sammy's on the Bowery, which Weegee described in *Naked City* as a place where "patrons prefer to dance with their hats and coats on." The photographer, whose tendency for hyperbole is evident in his publications, was not exaggerating this time. In this image, Shorty's nearly nude condition in the midst of other warmly bundled customers calls attention to the exceptional proportions of his limbs as well as to his diminutive height. The exposure of his unusually formed body, given more brightness and volume by Weegee's flashbulb, is likely the reason for this picture. Rather than human abnormalities, Weegee was interested in flesh, in urban bodies of all shapes and sizes (see, for example, pls. 11, 20, 27, and 38). However, whether he intended it or not, this composition does have a sideshow quality to it. Weegee's camera is looking down on Shorty, and the dwarf's presence as a spectacle is emphasized by what seems like the hand of a barker at right, revealing a circus attraction. In *Naked City*, the severely cropped negative presents Shorty celebrating with a hat announcing the arrival of 1945 (instead of 1943).

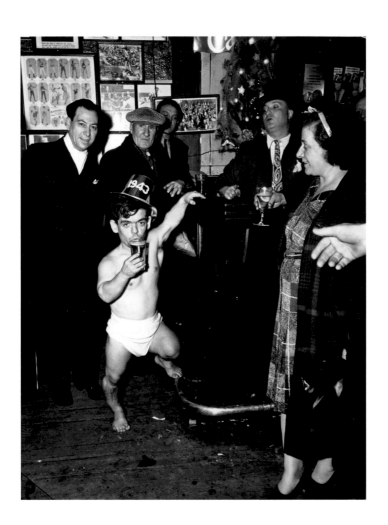

PLATE 40

Marilyn Monroe
March 1955

Gelatin silver print
23.6 × 19.1 cm
(9⁵/₁₆ × 7½ in.)
2003.99.2

The Ringling Bros. and Barnum & Bailey Circus was the inspiration for Cecil B. DeMille's 1952 Academy Award–winning movie *The Greatest Show on Earth.* The circus billed itself the same way while playing its annual engagement at Madison Square Garden in the 1940s. After World War II, however, the competition of television variety shows and theme parks caused attendance under the big tents to decline. In an effort to keep the circus viable, John Ringling North found a sponsor and brought "The Greatest Show on Earth" to TV in 1955. Marilyn Monroe (1926–1962) rode a pink elephant in the spectacular opening act. The actress was between contracts and husbands at the time. She hoped to form her own production company and find more serious acting roles. Nevertheless, Monroe

had gotten her start in male magazines, and this image by Weegee seems to perpetuate her role as pinup model.

By the mid-1950s Weegee himself was publishing with many men's magazines, including *Brief, Pageant, Playboy, Scene,* and *Stag.* Given the subject of starlet on circus elephant, the photographer was obviously not trying for a serious composition; however, if not cheesecake, Weegee's image is an amusing contrast to the young Richard Avedon's landmark fashion picture of 1955, *Dovima with the Elephants, Cirque d'Hiver, Paris.*

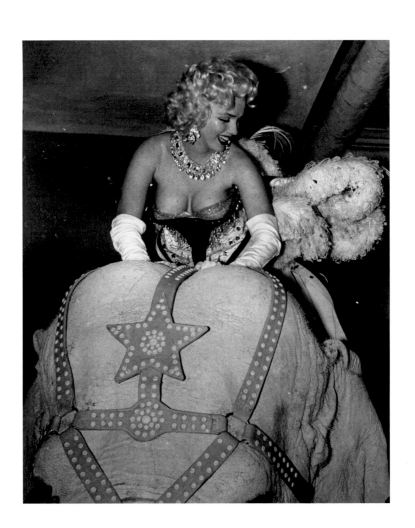

PLATE 41

My Mother in Law /
Human Sculpture

1959

Gelatin silver print
Image: 30.6 × 21.7 cm
(12 1/16 × 8 9/16 in.)
Sheet: 35.4 × 25.4 cm
(13 15/16 × 10 in.)
84.XM.190.6

Weegee "first started taking these unusual and funny pictures as an escape from the world of naked reality" (*Weegee's Creative Photography*, 1964). Although even he thought some of his first experiments were "pretty crude," he discovered that they sold (granted, the buyers were magazines like *Mad, Sick*, and the *Hobo News*). Once he had refined his use of kaleidoscopes, mirrors, and molded plastic lenses, fashion and family magazines (such as *Vogue* and *Life*) were interested. He had "hit the big-time" and "was so successful with my new kind of photography that I gave up the police beat . . . and concentrated on my creative work."

Saying in *Weegee's Creative Photography* that he had always been a satirist, Weegee explained his technique for printing through a piece of melted plastic in order to exaggerate a public figure's features and thereby produce a caricature. He also recommended combining these darkroom tricks, possibly adding patterned glass to the arsenal, to make photographic art that imitated both Impressionist and abstract painting. Surpassing the Spanish artist Pablo Picasso (1881–1973) seemed to be on his agenda, but distorting the *Mona Lisa* and parodying Hollywood celebrities also gave him great pleasure. In the same vein, he used a mirror, extreme masking, and other darkroom manipulations to satirize the stereotype of the mother-in-law.

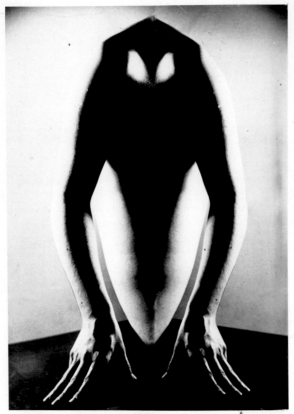

MY MOTHER IN LAW.

PLATE 42

The Fountain / Face of the Villiage [sic]

ca. 1955

Gelatin silver print
Image: 23.5 × 17.8 cm
(9 ¼ × 7 in.)
Sheet (trimmed to
first mount): 25.4 × 19.2 cm
(10 × 7 %₆ in.)
Second mount: 30.5 × 22.9 cm
(12 × 9 in.)
94.XM.14.4

PLATE 43

Greenwich Village Party

ca. 1955

Gelatin silver print
Image: 18.3 × 23 cm
(7 %₆ × 9 %₆ in.)
Sheet: 20.6 × 25.2 cm
(8 ⅛ × 9 ¹⁵⁄₁₆ in.)
94.XM.14.6

PLATE 44

Masquerade Couple, Greenwich Village

ca. 1955

Gelatin silver print
23 × 18.7 cm
(9 %₆ × 7 ⅜ in.)
94.XM.14.3

Weegee claimed in his how-to guide *Weegee's Creative Camera* that Greenwich Village was for him what the Montmartre section of Paris had been to the French artist Henri de Toulouse-Lautrec (1864–1901). Weegee photographed the area for decades and compiled selected images in a mock-up for a possible book. That group of pictures, introduced by his own text, was issued posthumously as *The Village*. His opening statement (optimistically assuming publication) reflects the increasing urgency he felt in recording the neighborhood: "Up to the time this book went to press I continually photographed the Village . . . compiling a memento of a place that seemed to be fast disappearing. New York University is tearing down all the old buildings and putting up more classrooms so they can teach Ceramics, Square Dancing, and primitive Painting à la Grandma Moses."

Although Weegee didn't live to see the publication of *The Village*, which included plates 42 and 43, he was able to include seventeen related images by way of example in a chapter on "Mood Photography" in *Weegee's Creative Camera*. Putting one's finger, "photographically speaking," on the element of mood apparently required flexibility: "On New Year's Eve I went to a rent party in a cheap Village flat. For fifty cents you bring your own bottle, your girl, squat on a bare wood floor, and share a few unusual sights. I keyed the mood in this one quickly. There was a shower in the kitchen. I asked a little girl with a nice figure if she would take a shower (I knew someone would before the night was over)." Plates 42–44 were used as part of a photomontage in a 1956 article in *Swank* magazine (see entry for pls. 45–47).

THE FOUNTAIN
FACE OF THE VILLAGE

PLATE 45

Jule's [sic], The Friendliest Bar in Greenwich Villiage [sic]

Before 1946

Gelatin silver print
Image: 33.2 × 26.6 cm
(13 ⅛ × 10 ½ in.)
Sheet: 35.7 × 28.2 cm
(14 ⅛ × 11 ⅛ in.)
2003.99.1

PLATE 46

San Remo

ca. 1945

Gelatin silver print
22.6 × 19.6 cm
(8 ¹⁵⁄₁₆ × 7 ¾ in.)
2003.99.4

PLATE 47

Some Do Their Home Work There

Before 1946

Gelatin silver print
34.1 × 27.1 cm
(13 ⁷⁄₁₆ × 10 ¹¹⁄₁₆ in.)
87.XM.65.7

Once mounted by Weegee on black paper as he assembled a mock-up for a book, plate 45 bears evidence of his working method in the form of a typed caption affixed to the picture: "THIS IS JULE'S... THE FRIEND-LIEST BAR IN / GREENWICH VILLIAGE.. AT 10 TH ST & WAVER LY PLACE / HANG-OUT FOR... WRITERS ... ARTISTS.. & [strikeover] / EVEN THE MUSICIANS WHO PLAY ACROSS THE STREET IN / NICKS.... DROP IN HERE FOR A QUICK ONE...... / THIS GIRL FOUND PEACE PLAYING SOFTLY A RECORDER / (AN EARLY ELIZIBITIAN INSTRUMENT)." In *Weegee's People*, a different cropping of this scene appears in the section "Saturday Night." It is placed, without a caption, on the same page as plate 47. Further into the section, an edited version of the caption runs under an image of a bartender at Julius's.

Weegee's caption for plate 47, although it was not finally used with the picture in *Weegee's People*, is found in the artist's archive at the International Center of Photography: "'Some do their home work there',

Waldorf Cafeteria, called the Wax Museum because everyone sat still waiting for something to happen." Recommended in the book *Greenwich Village: Today and Yesterday* (1949), by the photographer Berenice Abbott (1898–1991) and the writer Henry Wysham Lanier (1873–1958), as a "late-at-night meeting place of many real Village artists and characters," the Waldorf included among its patrons the Abstract Expressionist painters, whose work had not yet received wide recognition. However, the artist Weegee includes here appears to be a student of Pablo Picasso's earlier Cubist style rather than one of the new avant-garde.

Plate 46 shows the San Remo bar, cited in *Greenwich Village* as a place with the reputation of "drawing most of the younger Village artists and writers." A 1956 article in *Swank* magazine about Maxwell Bodenheim (1892–1954), an infamous Village personality who frequented the San Remo, featured a double-page photomontage of dozens of Weegee's Village pictures, including plates 42–44.

THIS IS JULE'S... THE FRIENDLIEST BAR IN
GREENWICH VILLIAGE.. AT 10 TH ST & WAVER LY PLACE
HANGOUT FOR... WRITERS ... ARTISTS.. & XXXXXXXXXXX
EVEN THE MUSICIANS WHO PLAY ACROSS THE STREET IN
NICKS.... DROP IN HERE FOR A QUICK ONE......
THIS GIRL FOUND PEACE PLAYING SOFTLY A RECORDER
(AN EARLY ELIZABETHAN XX

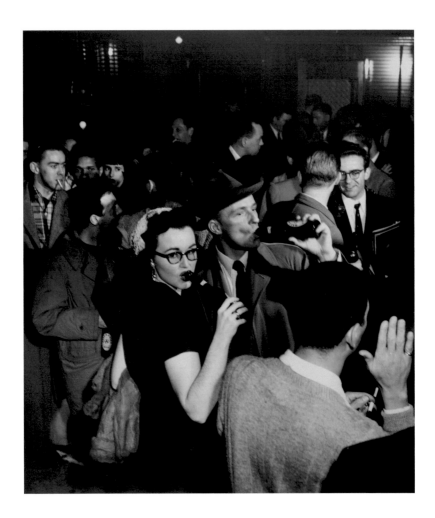

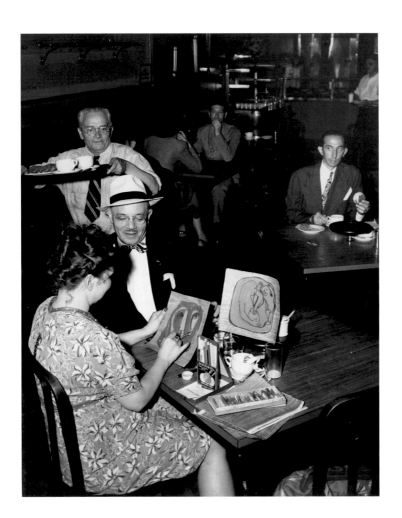

PLATE 48

The Park Bench

ca. 1945

Gelatin silver print
Image: 33.8 × 27.3 cm
(13⁵⁄₁₆ × 10¾ in.)
Sheet: 35.6 × 28.7 cm
(14 × 11⁵⁄₁₆ in.)
84.XM.190.50

Weegee chose this unusually tranquil, sunny scene to introduce the first section of *Weegee's People.* He wrote in the introduction, "I spent all summer in Washington Square Park, resting after the publication of my first book, *Naked City,* hence the pictures in the chapter titled 'Park Bench.'" In fact, the Getty's print, with old tape on the edges and unedited caption text on the verso, is probably the very one sent to the printer.

This Greenwich Village park is known for the white marble Washington Arch, barely visible behind trees at the upper left of the composition. The distinguished architectural firm of McKim, Mead, and White designed the landmark at the base of Fifth Avenue to memorialize the centennial of the inauguration of George Washington. In addition to the late-nineteenth-century triumphal arch, the park also contains heroic sculpture, such as the statue of Giuseppe Garibaldi, which Weegee includes on the same axis as his more animated figures— New Yorkers working, napping, and painting. Although the reclining blond is literally the central subject, the young artist, possibly a student at nearby New York University, is the key to this outdoor scene. She is the creative spirit of the place; her view encompasses the magnificent arch Weegee won't show us.

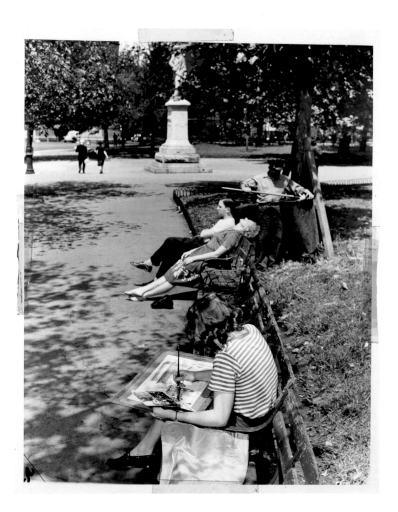

PLATE 49

Alfred Stieglitz

ca. 1950 gelatin silver print
from a May 1944 negative
26.8 × 33.8 cm
(10⁹⁄₁₆ × 13⁵⁄₁₆ in.)
84.XM.190.4

The way Weegee tells it in the "Personalities" section of *Naked City*, he finally approached and spoke to the elderly photographer Alfred Stieglitz (1864–1946) because he frequently saw him, walking alone in a dazed state, on the sidewalks of midtown Manhattan. After an awkward moment, according to Weegee, Stieglitz invited him into his small gallery at 509 Madison Avenue. They conversed while Stieglitz, still bundled in his heavy black cape, rested on a cot below the modern masters he had on exhibition. An American Place was the last of three galleries the artist had maintained in New York for almost forty years. Over the decades, Stieglitz had made every effort to bring photography, as well as avant-garde art in other media, to the attention of an American audience.

Weegee refers to Stieglitz as "the most famous photographer in the world," but represents him as frail and nearly indigent, seemingly camping out in a commercial space. A profile of the much younger *Police Gazette* photographer Pat Rich, shown working in a circus setting, follows that of Stieglitz in *Naked City*. Both seem to be heroes for Weegee, but it is hard to know whether he is, by association, using them to boast about or reflect upon his own life and the elusive nature of fame.

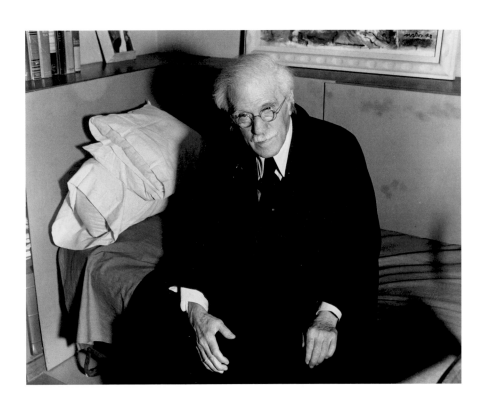

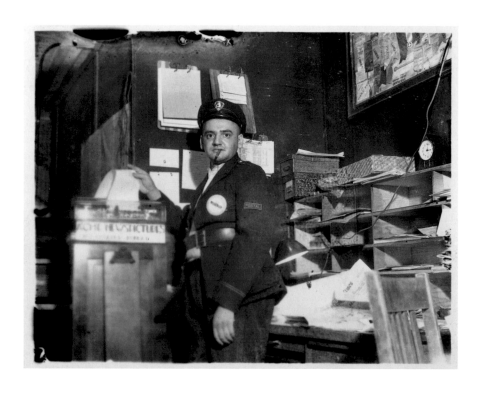

George Watson (American, 1892–1977).
Weegee at Acme Newspictures, Hollywood, California, 1952.
Gelatin silver print, 8.9 × 11.5 cm (3½ × 4⁹⁄₁₆ in.). 2001.66.7.
© The Watson Family Photo Collection.

An Elusive Fame:
The Photographs of Weegee

David Featherstone: Typically, when we conduct these colloquia for the In Focus series, we consider an artist's work over a broad period of time and take a biographical approach. Today, with Weegee, we're going to look at and discuss a set of pictures made over a relatively short period of time, roughly a decade in the 1930s and 1940s, and then into the 1950s. This focus not only reflects the Getty Museum's holdings but also covers the work for which Weegee is best known. Before we consider the photographs, however, let's briefly talk about the difficulty in determining his biography.

Weston Naef: Almost all the photographers who have been included in the In Focus series up to now have been the subjects of traditional biocritical studies that have drawn from a number of sources—letters, documents found in public archives, firsthand recollections recorded from those who knew the person. Such information about Weegee appears to be nearly nonexistent, except for what he recorded in his 1961 autobiography, *Weegee by Weegee*. I would like to establish what other resources we might be relying on today, the point being that many other sources also start with *Weegee by Weegee*.

Colin Westerbeck: Miles Barth's 1997 book, *Weegee's World*, is very important because he clears up a lot of things. One must understand that in *Weegee by Weegee* the photographer is not completely truthful with the facts about his life.

WN: And that's the problem. My sources are almost exclusively *Weegee by Weegee*, and, therefore, mine is a limited perspective.

Miles Orvell: My sources also include Louis Stettner's 1977 book, *Weegee*, and a few other things, but these are the basic sources.

WN: Have you ever found a letter of Weegee's, either by him or written to him by another person?

MO: No.

Cynthia Young: My biographical information also comes from the many short interviews Weegee did with reporters in the 1950s and 1960s, when he was peddling his name and his distortion work. His voice, edited by a third party, is apparent in those interviews. As for letters at the International Center of Photography archive, there are very few from the 1940s. They're from editors and are very short. They don't contain information about his life. There are many letters—really postcards— that he wrote later to Wilma Wilcox, when he was working in Europe.

WN: How much information can be derived from anything inscribed on the negative sleeves?

CY: In terms of biography, little. Character, yes.

Judith Keller: In addition to these published sources, there's also an interview with Wilcox that's been published. I found the films, especially *Weegee in Hollywood*, very interesting. It doesn't help us out with the dates, but it shows what his life was like in Hollywood. There have been other articles by students and people who claim to have spent time with him, but how much of this is accurate, I don't know.

Michael Hargraves: There are several exhibition catalogues, including one from the San Francisco Museum of Modern Art in 1984 that was based on the holdings of a collector, as well as an interview, recently found in the Library of Congress, that Mary Margaret McBride conducted in July 1945. And I've seen odd little things on the Internet that are now coming to light.

MO: Has anyone come across the *New Yorker* profile of Weegee that he refers to?

MH: I checked the *Readers' Guide to Periodical Literature* for Joseph Mitchell, whom Weegee said had done it. It may have been written, but it was never published.

WN: Has anyone turned *PM* page by page?

CY: We have at ICP. We have copies of almost all the pictures and articles he did for *PM*.

Ira Richer: My knowledge is from a period of about five years when I met with Wilcox numerous times. We looked at many photographs, and she related stories as she remembered them—Weegee's quotes and her knowledge about the photographs.

DF: Ira, please tell us who Wilma Wilcox was.

IR: She was a Quaker, a psychologist from Columbia University. She was also a photographer, and she met Weegee at the Photo League. She was living in the Bronx at the time, and he traveled up to visit her. She described herself as "a friend to Weegee."

DF: They lived together, but did they ever marry?

IR: I don't think so. She never called him her husband, even in a casual discussion. She called him Weege or Weegee. She never called him Arthur Fellig or Arthur.

JK: But they lived together at the end of his life.

IR: And she took care of him during his diabetes-related illnesses. She worked for the Salvation Army as a psychologist for many, many years.

MO: That's interesting to know, because at the Salvation Army she would be dealing with people like those Weegee sometimes photographed.

DF: We generally know of Weegee as a New York photographer, so it's perhaps ironic that the first image we're going to look at today is a portrait made of him in Los Angeles in 1932. It's titled *Weegee at Acme Newspictures, Hollywood, California* (see p. 90).

WN: This picture came to the Getty Museum from the Watson family studio, which George Watson established in the teens and which later became an outlet

franchise for Acme. When we were surveying the Watson family archive, which still exists in a wood-frame house in Hollywood, where it's been since the 1920s, Delmar Watson, who is seventy-eight years old and the surviving keeper of this archive, had wonderful recollections of Weegee when he arrived in Los Angeles, apparently sent by Acme. Weegee went to work in the darkroom for Acme in New York around 1924. He resigned in 1935 to become a freelance photographer. And sometime between 1924 and 1935—we assume that the date has been documented as 1932, which jibes with the Summer Olympics in Los Angeles—Weegee came here to work with the Watson family.

The Watson family became rather celebrated for their pictures of crime scenes, and Weegee may have learned about the potential appeal of that kind of picture from them. So we are starting this discussion of Weegee's very curious biography with the somewhat obscure fact that he learned something important about his craft here in Los Angeles. This photograph shows him standing in the Acme studio, which is littered with papers. His hand is on what would appear to be a wire transmission device. He is wearing a uniform of some kind.

CY: This is a fascinating bit of information you're bringing forward. I wonder why Weegee omitted this in his autobiography.

JK: Other than being in a different city, it probably wasn't an experience he really thought was worth mentioning. We don't know exactly how long he was here. I agree that it's odd he doesn't mention it. But I think the job was just a continuation of the darkroom work he was doing in New York, and that wasn't what he really wanted to do.

CW: At this time, I think it would have been very unusual for a low-level functionary to be moved all the way across the country, and that raises the question of whether Weegee did it on his own initiative. If so, then that raises a further question of why it wouldn't be a significant part of his biography. And if Acme really did send him to L.A., it suggests that he had some very extraordinary skill or was sent on a mission that was particular to him, and he was not just a low-level functionary, despite the evidence of the photograph before us.

MO: What I find so striking about this picture is how different it is from all the other images that we have of Weegee. He's in a uniform, standing at this machine with the paper in his hand, and he's working for this company. In later shots, once he becomes Weegee, he is very much his own man, and fulfilling the persona that he was creating. He is a reporter, a photojournalist, he is on the job, he is working out of the back of his car—all those images suggest the autonomy and independence of a photographer, which is totally lacking here.

What strikes me as amazing is that he was *not* Weegee for so many years, that it was only at about the age of thirty-five or thirty-six that he actually became the freelance photographer that allowed him to express himself more fully. Thinking about this in terms of careers of similar figures, the only example that I can think of—which may seem far-fetched—is Walt Whitman. Whitman was a journalist, an editor in Brooklyn for many years, and just around the age of thirty-five he decided that he would reinvent himself and grow *Leaves of Grass*. He suddenly came on stage and was forever different. Weegee underwent a similar kind of metamorphosis, and this is an interesting document from the stage at which he's in the cocoon.

DF: He was born Usher Fellig, then became Arthur Fellig. How did he become Weegee?

WN: Why don't I quote his own words, from *Weegee by Weegee*: "Somehow, the word spread that I was psychic because I always managed to have my pictures in the hands of the paper before any news of the event was generally known. I had my ways. I also had my ways with the girls . . . they, too, thought I was psychic. In fact, the word spread that my camera had an X-ray lens, that I photographed right through the girls' clothes—so for a while, the girls refused to pose for me. However, the girls around Acme gave me my name after the current rage, the ouija board: 'WEEGEE.' I liked it. (The spelling is mine.) I've never known a better name or a better photographer."

MO: Miles Barth talks about *squeegee* as another possible source for the name.

IR: That's the story I heard through a friend of Weegee's. He was working for Acme as a "squeegee," which meant he wasn't even a printer. At the end of the darkroom

process, he was responsible for getting the water off the prints after they were washed, so he got called "squeegee."

MO: What's interesting is that it's a one-word name. It reminds me of Houdini, another Jewish immigrant who created himself with a one-word name and an aura of magic and mystery.

DF: The next photograph we'll consider was made in June 1943, by which time he was well established as Weegee. This is titled *Tenement Sleeping* (pl. 20).

WN: One fact related to this photograph is that Weegee grew up on the Lower East Side of New York, which was the traditional destination for immigrants to the United States, starting with the Irish, then the Italians, and proceeding to the Eastern Europeans, such as his own family.

JK: I think of Weegee as someone who could have been a Lewis Hine subject. Hine photographed all the newsboys around 1910, when Weegee was arriving from Austria with his mother and siblings. He attended school for only a few years after that and had a series of odd jobs, including selling newspapers on the street.

IR: He had lived the photographs.

JK: Yes.

WN: One of the survival rules in tenement life was how to get a good sleep in the stiflingly hot New York summer nights. Here we see an obese man, from above, sleeping on a blanket with nothing on but his underwear. One idea about the art of photography is that a picture can represent something out of the maker's own memory. In this image, are we seeing something as much about Weegee's own life as it is a document?

IR: I think we're seeing envy, because this man is sleeping, and Weegee's work placed him on the streets at night. He must have been a somnambulist. It takes a certain type of man to do work that requires being up when everybody else is sleeping and sleeping when everybody else is up.

JK: He made many pictures of people sleeping over the years—in bars, parks, movie theaters.

CW: Pictures like this are amazing to us, the children of air-conditioning, but thirty-five thousand people used to sleep in Central Park every night, right up through World War II, to escape the heat of tenement life.

I think Weston is quite right. There are certain Weegee pictures where he's looking at someone whose life turned out the opposite of his. In others, he's looking at himself, and this picture is indeed a mirror of his own sense of self. He's responded to something that either goes back into his own past—things he did himself, like sleeping on a fire escape—or to things that he can identify with in some other way.

The question of how someone living in the oppressiveness of New York at this time—which we think of as something that suppresses personality and individuality—can see a reflection of himself in the anonymity, say, of this picture, then turn that around and develop it into a public persona, is part of what we're pursuing today. It's something you have to trace through the pictures.

IR: And there's humor in this photograph. That's what makes it something more than a documentary image by Hine. The man is in a fetal position, and he also looks like he's pregnant. There's a double entendre.

JK: Your point is a very good one. Aside from being about the heat in New York in June, this is about the man's body—about his shape and the fact that he's practically nude. There's a lot of sensuality about it. It's not an erotic picture, but it's all about the body. Weegee may not have been thinking about his own body, but over and over in these pictures he looks at the shapes of people's bodies.

IR: He's looking at the isolation of a form in space.

MO: This is also about where Weegee is taking the picture, very deliberately looking at this figure from above. He would go into the tenements—knowing how they were constructed and how to get to the spot he wanted—and shoot from the angle that he most desired. In this case, it's a documentary picture that is reminiscent of the aerial perspectives that Modernist photographers like Alexander Rodchenko and Paul Outerbridge were using in the 1920s—looking down on objects to create an unusual distortion.

CW: Let me return to the point Judy was making about the sensuousness of this picture. Weegee certainly had learned by this point that his flash was going to throw all that hairiness into great relief. I think his mind went from loving this effect to loving what infrared film does. He often made society figures look sleazy, unshaven and unkempt. He liked that, and he always depended on his equipment to produce that in his pictures.

WN: Is Weegee a voyeur here, looking down at a man whose body he is admiring?

JK: I don't think so. I think he found the shape of the body very interesting. It was something he was always looking for in people.

MO: The word *voyeur* is key here, because something else this picture brings up is the way that Weegee used the camera as an instrument of transgression. We're going to see a lot of that as we progress. It's something that perhaps he could justify in terms of getting an image that was more authentic than he might get otherwise. He used the word *unmask* a lot. A sleeping figure is someone who cannot have a mask, so the most genuine photograph you can take is of someone sleeping.

DF: Colin's mention that Weegee used infrared film relates to this next photograph, *Audience in the Palace Theater*, dated about 1953 (pl. 30). The infrared film made it possible for him to photograph in the darkness without a flash.

WN: I think it's important to relate this to Weegee's autobiography. Something that has always fascinated me is that when he was fifteen he decided to learn to play the violin. He took lessons at a settlement house and paid a small amount to do so. He says in his autobiography that this qualified him for a job in a movie theater playing music for silent films. Two things happened as a result of his spending a great deal of time in such theaters. First, he became a fan of cinema—in his autobiography he says that when he wanted to relax, he went to a movie. Then, later, he left New York for Hollywood to try to make it in the motion picture business. He stopped playing the violin in theaters once talkies came in, but he returned as a voyeur photographing a crowd of people. Right at the center of this picture is a couple enjoying what they think to be a private kiss.

JK: Isn't it true that, in at least one instance when he photographed a couple in a theater while a film was playing, it was staged? He knew the people, and they agreed to kiss for him, but I don't know if this is that case.

MO: He might have hired them to kiss?

JK: Yes. He certainly staged other things.

CW: That just adds another level of complexity, because people do go to movies to neck.

JK: Yes, of course.

CW: And when people at the movies neck, they cease being voyeurs and become the stars on the screen. In their erotic involvement, they are now the attraction. So the ambiguity of who is the subject and who is the viewer, and the way that the individuals looking at the screen now become worth looking at because they're doing something illicit, adds to what one must assume was the deliciousness that Weegee felt being—to return to Weston's word—the voyeur himself. He got to watch the people not only watching something else but sometimes engaging in their own illicit lovemaking, perhaps mirroring what was on the screen.

CY: The subject of kissers recurs again and again throughout his career. One of the things that surprised me in looking through so many photographs in the archive was that they were hardly all murders. There are certainly disastrous situations, but many are lovers, kisses.

MO: That's a reflection of his loneliness and vicarious enjoyment of people who were in some kind of relationship. Weegee's interest in the kiss is part of the fantastic creation of himself as a lover, which he relates, perhaps mythologically, in his autobiography.

IR: I remember that Wilcox said he was very insecure when it came to women. When they first met, he told her, "I would come over more often, but you need to get rid of all those pots and pans." She said she couldn't figure out what that meant. It's the opposite of forming a household. She said he seemed to have a lot of trouble having a domestic life. Look at the way he dressed! It's not the best way to appeal to women

to present yourself as unshaven, unwashed, and disheveled. There's this contradiction in Weegee of wanting relationships but not being able to form them, and then viewing other people's abilities to form them. He was a voyeur of relationships.

MO: The cigar is another emblem of that, I think. It could serve as, if you will, a phallic symbol, but at the same time, a kind of repellent object. The idea of kissing someone who smokes cigars continually would be something you would have to overcome.

WN: He described himself as smoking twenty cigars a day.

MO: Right. A cigar is just a cigar, but twenty a day is not just a cigar!

WN: Look back to the portrait in the Acme studio (p. 90), in which he is smoking a cigar. Already, in 1932, it was a part of his self-image.

JK: With the cigar, the unshavenness, and the clothes that don't fit quite right, he might have thought he was presenting a very masculine image.

CW: Ira's story about the pots and pans reminds me of what I think is the most eloquent passage in *Naked City*, which accompanies the picture of bundles of newspapers thrown on the sidewalk. It's in the beginning chapter, "Sunday Morning in Manhattan": "This is the most peaceful time of the whole week. Everything is so quiet . . . no traffic noises . . . and no crime either. People are just too exhausted for anything. The Sunday papers, all bundled up, are thrown on the sidewalk in front of the still-closed candy stores and newspaper stands. New Yorkers like their Sunday papers, especially the lonely men and women who live in furnished rooms. They leave early to get the papers . . . they get two. One of the standard-size papers, either the *Times* or *Tribune* . . . they're thick and heavy, plenty of reading in them, and then also the tabloid *Mirror* . . . to read Winchell and learn all about Cafe Society and the Broadway playboys and their Glamour Girl Friends. Then back to the room . . . to read and read . . . to drive away loneliness . . . but one tires of reading. One wants someone to talk to, to argue with, and yes, someone to make love to. How about a movie—NO—too damn much talking on the screen. 'But Darling I do love you . . . RAHLLY I do,' . . . then the final clinch with the lovers in each other's arms . . . then it's even worse, to go back alone to the furnished room . . . to look up at the ceiling and cry oneself to sleep."

That's so poignant. You can't help feeling that this is a guy who lives in a furnished room across from police headquarters, and he is trapped in this loneliness and isolation, feeling himself this person in the big city who doesn't have a friend, who can't make a human contact, and whose voyeurism is somehow a substitute.

JK: It's right out of an O. Henry story, which are practically all about people who live in furnished rooms.

CW: Earl Wilson called Weegee "O. Henry with a camera" in one of his columns.

WN: Doesn't it strike you that the quality of the writing there is quite exceptional?

CW: That's why I wonder how many of the stories in *PM* he wrote, because he's very good.

IR: As Colin read that, it reminded me not of a photographer, but of a detective.

JK: Sure. Sam Spade. Mike Hammer.

MO: Weegee has a similar kind of polarity between the tough guy and the sentimentalist. Although he certainly was a great storyteller, there are many times in his writings when he verges close to and beyond the bathetic—not the pathetic—where there's a lot that's over the line and sentimental.

JK: Melodrama.

MO: Yes, melodramatic. I think Weegee's sensibility is one of the really fascinating things about him, and the way that he is an embodiment of popular culture.

IR: He's basically an antihero.

JK: Which is what the detective novel heroes were.

IR: He's not well pressed, and nobody wants him in the room, but he's still heroic in his role . . .

JK: Right. He works at night, he lives by himself . . .

MO: The toughness of a guy who's seen everything.

CW: He could be extraordinarily sentimental, but he could also be incredibly predatory in some of his photographs.

CY: I think the word is still out about his writing and the relationship he had with an editor. One thing I've noticed in his publications is that *Naked City* has the most text until the autobiography, *Weegee by Weegee*. In *Weegee's People* and *Naked Hollywood*, there's less and less text, to the point where there are just images. I don't know the relationship between him and his editor with *Naked City*, but I suspect there was a lot of attention to the writing there, and then it never fully developed in the other books.

IR: Wilcox said that he had a great deal of trouble getting *Naked City* published. One time he went to a publishing house, and they said they hadn't read it yet, but he found the copy of the manuscript and the original photographs in the toilet. She said that made him cry!

WN: Let's return for a moment to the idea of voyeurism. Weegee talks about a number of his friends throughout, but early on we don't learn about many of them except for a man named Tony, who was his part-time chauffeur and who accompanied him to the brothels. His favorite place was May's, on Amsterdam Avenue. My question is if he ever photographed his friends. Is there a photograph of May? What he said he liked about May's was that "here, there was no rushing. A nice homey atmosphere and the girls were beautiful." But what really struck me was when he described his favorite part of May's: "May was a girl after my own heart. She had peep-holes in the wall so that you could watch the action." He goes to May's for its homey atmosphere and to watch other people making love through a peephole?!

MO: That's amazing. The absence of personal photos is something I hadn't thought about in this context before. Are there personal photos in the Weegee archive? I haven't seen any, and I'm wondering if he just didn't take them. Perhaps he considered himself so completely a professional—having a subject of news events, working for a purpose, selling a picture—that the idea of creating a family album was just alien to him.

WN: But there are a lot of self-portraits. That's the curious thing.

MO: That's part of his creation of the self, which is part of the business of being Weegee.

IR: What it suggests is that, perhaps in his own mind, and perhaps in the reality of his life, he didn't have a life outside of his engagement with the city as a crime reporter. The radio was always on. He said that even when he was trying to sleep, he always had the radio on low so, if a police call came through, he could jump up and run out.

MO: There is an incredible work ethic here, which is something you don't necessarily think of in connection with Weegee. But he came from a background where you worked hard to make it, and you had to work hard to stay on top and achieve a certain level.

DF: We've established Weegee's character in a very interesting way, I think. And Ira's mention of Weegee as a New York crime reporter is a good segue into a series of photographs that may have resulted from him having his police radio on all the time. The first of these is titled, variously, *Transvestite* and *The Gay Deceiver*, dated about 1939 (pl. 11).

WN: In Weegee's autobiography, I was struck by the many times he refers to his attraction to the opposite sex and by the subtheme that he was not able to succeed and envied people who could. Here, he is looking at a man in women's clothes, and there is something sexy and slightly erotic about the picture.

CW: Part of what he's attracted to here—and, indeed, it is erotic, but not necessarily homosexual—is the uninhibited exhibitionism. What he envies is this guy's abandoning of himself to whatever it is that turns him on.

IR: I disagree with that. I feel Weegee is always in synch with his subject matter, and I'll use this as an example. The subject is taking this picture, not Weegee. Weegee completes the gesture in synch with the subject. They are together at that moment.

WN: That synchronization has an erotic element to it; that's what I'm getting at.

IR: Right, but he had to be in synch with the subject matter in order to take that picture.

JK: That fellow is clearly posing. He's very happy to pose for Weegee's camera.

CY: The question is, if Weston's point is correct, why aren't there more pictures like this?

IR: Nobody can know exactly the depth of Weegee's feelings, but he must have communicated with the subject enough to understand the gestures and complete the photograph. He did the same thing with Marilyn Monroe—she smiles, she controls the photograph, he completes the gesture.

MO: There's an interesting quote related to this in *Weegee by Weegee*: "A telegram from a man's magazine; they wanted pictures of abnormal fellows who liked to dress in women's clothes. I would call the editor and tell him that what was abnormal to him was normal to me."

WN: That's very revealing.

JK: But by *normal* he may just mean, "This is one of my subjects every other evening." He photographs murders, and he photographs transvestites.

MO: That's part of it, but I think it's also part of his acceptance. Again, I come back to Whitman in terms of this egalitarian acceptance of people's deviance. Who they were, what they were, didn't matter—they were part of the human spectacle.

JK: There are some other things that we can say about this picture in terms of how it might relate to later photographers. Weegee's two best-known books had just come out before Andy Warhol moved to New York. We know Warhol had *Naked City* in his library, but we don't know when he started looking at it. I think in many ways Weegee was a role model for Warhol.

MH: In an entry from Warhol's diary of April 15, 1984, he says: "It was a miserable day, rain pouring down. . . . I stayed home and did research, looking at the Weegee pictures. He's so great. People sleeping and fires and murders and sex and violence. I want to do these kinds of pictures so much. I wish I could ride around with the police. But I figure I can just do setups—use plants in my pictures."

JK: But Warhol did use crime photographs commercially. Some of his *Thirteen Most Wanted Men* were actually from mug shots of the 1930s and 1940s.

Weegee.
Self-Portrait with Andy Warhol, negative: 1965; modern print.
International Center of Photography.

MO: In many ways, Weegee's interest in the substrata of New York City also antic-
ipates Diane Arbus. But what's more interesting is how different this photograph
is from Arbus's typical treatment. This guy was out having a good time, at least at
this moment, even though he'd been arrested. There's an acceptance of who he is
here, both by himself and by the photographer. That is rather different from Arbus's
work, where the subjects have an almost tragic quality, although they're also heroic.

IR: There are photographs of Weegee and Warhol together (see above). Weegee went
to a party at the first Factory, and they posed together. He was deeply hurt that
Warhol did not acknowledge who he was. But of course, the tie-in between the two
artists is remarkable in the disaster paintings that Warhol created.

MO: Another interesting connection is that they were both children of immi-
grants, and each created a persona for himself.

JK: And they both started out in the commercial world and became recognized as
artists through great efforts of their own.

DF: Let's move on to another photograph, which is titled *Arrested for Bribing Basketball Players*, from January 25, 1945 (pl. 15).

CW: The basketball players were from Brooklyn College. At that time, City University games were probably not small beer at all, and I would think it probably wasn't too hard to corrupt Brooklyn College kids by waving a little money at them.

MO: I think this is an example of Weegee's inventiveness. Here are two criminals who don't want to be photographed. They are covering their faces. Weegee presumably wanted to capture them uncovered, but they insisted on concealing themselves, so he made that the subject of his picture. It's a brilliant image of shame and guilt, but it's also about the photographer as the self-appointed witness of society, the person who has the right to invade anyone's privacy in the interest of getting the picture. He has violated the rights of these people to an extraordinary degree, yet he complained, in *Naked City*, that "they gave me a lot of trouble as I tried to photograph them." It goes back to what we were saying about the role of the photographer. I wouldn't say he's being a voyeur here; he's being an invader of privacy.

DF: Is the man on the right also one of the gamblers?

CW: He's a detective.

MO: It's interesting that he closed his eyes at that moment.

CY: This picture brings up issues of Weegee's editing, because in a variant, the middle figure doesn't have his handkerchief up. It's not an interesting image; it's just a face. Over time, this present plate has become iconic Weegee, but if the man on the far right side had opened his eyes, it probably wouldn't have the same impact today.

WN: John Coplans, the artist, critic, and collector of Weegee photographs, wrote in the September/October 1977 *Art in America* about the medium in general that "no other art form rivals photography's capacity to be meaningless, to topple into a void." I've always thought of this image as one of those that's right on the brink of toppling into a void and being utterly meaningless.

JK: But look at what it shows us about the appearance of both gangsters and police

detectives at that time. They paid great attention to stylishness. They're dressed in nice suits, with appropriate hats.

CW: The detective is right from central casting. He's dressed like a gangster, and he's wearing a flashy, expensive necktie.

JK: Right. And the shirt is highly starched.

CW: They've arrived at central booking, I think. They must have come up in an elevator, and Weegee knew to stand outside the elevator and flash them the minute the doors opened.

WN: With its emphasis on gesture and expression, you can connect this to academic art, which had a concern for poses, expressions, and gestures appropriate to the subject. Here, obviously by accident, Weegee got a wonderful array of gestures, including the detective's hand in his pocket.

IR: It's very cartoonlike, so brief in information yet we know everybody's role. The hoods act like hoods, and the police officer acts like a police officer; he's either holding his gun or implying that he has a gun. Hands—gestures—are very important in photographs to show that a picture is more than just a portrait of a face.

CW: Weegee loved hands, and he knew that a hand coming forward could be very dramatic.

WN: The year 1945 was when *Naked City*, the book that brought Weegee his first fame, was published. It was also about the time that the Museum of Modern Art acquired some of his pictures.

DF: How did *Naked City* come about?

JK: Weegee had a show at the Photo League in 1941. Edward Steichen acquired a few prints for MoMA in the years after that and included them in two shows in the 1940s. Weegee talks in his autobiography about giving a lecture at MoMA, after which people came up and told him he should put his pictures together in a book. We can't find any other evidence that he actually gave a talk at MoMA, so I don't know whether that's mythical or not. But his work was getting out there. People were seeing it in a

gallery or museum setting, and I'm sure he got feedback that made him feel that there was a possibility for a publication.

MO: The form of *Naked City* is interesting. It's in the tradition of the photo-text books that came of age in the mid-1930s. What Weegee did is similar to what Richard Wright did in *Twelve Million Black Voices* [1941]. Within each chapter, Weegee created a narrative that is carried by the pictures, which are briefly captioned. It's a successful integration of images and captions; you experience them both as part of a flowing narrative. However, I think what's inevitably sacrificed in any picture book, and especially where the text is integrated as it is in this book, is that you look at the pictures in terms of the text, but then you tend not to look at the pictures again. The text has a somewhat limiting function.

JK: It should also be compared to *American Photographs*, Walker Evans's 1938 book, in terms of the design and the text. It's a very different format, but it's a narrative set up by a sequence of one photographer's pictures. Weegee writes a little of his own narrative and has words accompanying most of the images. Evans was trying to create a narrative just through pictures. Both of them represent very American styles. Weegee's, of course, is the photojournalistic tradition, and Evans's is the art photography tradition. They are not usually talked about together, but I think that it's worth comparing them.

MO: Weegee seems to have invented the structural approach that Garry Winogrand would use in his work, to look at thousands of pictures and group them by subject. Weegee did it by the chapter, where Winogrand would do it by the volume. I think in some ways *Naked City* is an influential and pioneering book in this genre.

DF: Doesn't that approach serve to throw the attention back on Weegee as the photographer?

MO: Definitely, because he's creating the narrative as a narrative, as a story that he's responsible for.

CY: By combining separate news stories into one, he's taking the liberty of creating a fiction from what was originally published in newspapers and magazines under very different contexts.

CW: There are passages where what I call a symbolic narrative starts to emerge, where pictures that don't have anything to do with each other play off of each other as if you're watching a movie that has a purely symbolic structural development. Of course, the person who is going to bring that approach to a level that, in my opinion, Weegee never dreamed of is Robert Frank in *The Americans* [1958].

WN: Can we establish when Weegee began to see himself as an artist? We know from Judy that he showed his work to Steichen at MoMA in the 1940s, and Steichen acquired some photographs. So at that point Weegee had to have seen himself as an artist.

CW: I can understand Weegee's being impressed with the notion that he could rise to this new level of dignity in society. At the same time, this was someone who knew how hard you had to work to keep a career going. I wonder whether becoming an artist was just a new phase he thought he could go on to when the murder pictures were beginning to run dry.

IR: The murder pictures started running dry during the war—Weegee complained that all the best thugs were being drafted. And like a lot of people in the 1950s, I'm sure he saw the need to reinvent himself. Wilcox said that he struggled with the notion of being an artist.

MO: In some ways, that was the kiss of death for Weegee. When he saw himself as an artist, it was the end of his art. He reclassified himself and no longer allowed himself to be the demotic artist that he was so fully. In a way, *Naked City* is a kind of wonderful accident. It's a culmination of everything he'd been doing for ten years. It's a great work of popular art. But after that, he didn't know where to take it, and what he did was increasingly disappointing. *Weegee's People* has some leftovers that he wanted to include in *Naked City* and didn't have room for. *Naked Hollywood* is just totally pandering to the idea of being nude. In *Naked City*, *naked* means a revelation of the real city. In *Naked Hollywood*, it's just bare behinds.

CW: So, among other things, it was a bad career decision to become an artist.

MO: Yes.

DF: *Off Duty Cop Does Duty, Kills Gunman Who Tries Stickup*, from February 3, 1942 (pl. 9), is the next photograph we're going to discuss today.

CW: I wanted to talk about this image, because the picture and the story that was published about it in *PM* do not jibe. The story in *PM* is that an off-duty cop was in a social club on Broome Street, and a guy came in to rob the place. The cop didn't get his hands up fast enough to suit the guy, and the guy turned toward him. And the reason the cop didn't get his hands up fast enough was that he was pulling out his service revolver, and he shot and killed the guy right on the spot. But this body is out on the sidewalk, not inside a club. Could it be another body? Weegee always talked about how he had so many pictures of dead bodies, he didn't know which one was which. What I'm getting at is that the fiction doesn't start just with *Naked City* or by making it into a movie. The fiction is already there. I think if you went through all the *PM* and *Daily News* stories and tried to match what the pictures showed with what the narrative was, there would often be a disconnect that suggests the narratives are made up. And that's why it's interesting to know whether Weegee was writing the articles himself.

WN: You can begin to make up a number of stories about this picture. One possibility is that the man was shot inside, but at the door, and staggered out and fell on the street.

JK: Right. *PM* cropped this to make it tightly horizontal, almost as if he were in some sort of tomb.

CY: The full negative is actually a horizontal, but there is no more information.

MO: I wonder whether the revolver was placed there as a prop.

CW: The gangster legend, of course, is that the assassin puts machine oil on the handle and trigger of the gun so that it will not hold fingerprints. He throws the gun on the floor, and then who's to say whose it was?

JK: This poor fellow the cop killed apparently never got a shot off, but when you look at this cropping of the picture, my thought is that this is the gun that this fellow was shot with, that some assassin had dropped it.

CW: Right. It looks like a hit, because that's the iconography of gangsters.

JK: And then you find out that an off-duty cop who happened to frequent the same club shot him. Weegee knew what the crime scenes usually looked like, but I don't know whether he was trying to suggest another scenario.

WN: Something that is essential to Weegee's aesthetic is his use of flash, and here it is abundantly apparent. Again, I want to quote Coplans, who I think is one of the most astute observers of Weegee's art. He writes in *Art in America*: "Weegee's use of flash . . . creates a luminous ovoid shape from the dark visual field, a clear center whose edges fade. This effect gives a startling nearness to the image. We momentarily feel that we ourselves are there observing the scene."

That description applies to what we're seeing in this picture. The first part is a description of a painting, and the second part is a description of a photograph. Coplans started his life as a painter and then became a photographer. One eye is looking at the picture as a painter; the other eye, through his new career as a photographer. His understanding of the complexity of Weegee's images is that they have a strange crossover between something very real and something totally fictional, like an Abstract Expressionist painting or Color-Field painting.

Let's try to get a sense for this newly evolving person Weegee was becoming and how he got *Naked City* published.

IR: It was published by Essential Books, part of Duell, Sloan and Pearce, a big New York publisher.

WN: Weegee talks about going there and meeting with an editor, Frank Henry. They went across the street to the Champs Elysées restaurant, a high-class bistro. We're not talking about a slob here, but somebody who has reinvented himself and can knock on the door of a Madison Avenue editor and have him say yes. And four years later, Weegee was able to come to Hollywood.

JK: Universal brought him to Hollywood. They had bought the rights to his book— basically they bought the title.

WN: I'm trying to figure out how he did all this. The name Weegee was like magic.

CW: Duell, Sloan and Pearce was a very ritzy publisher, so he was moving in some pretty classy circles. But he also could have had entrée to those people through *PM*, because that was a very sophisticated newspaper. The publisher made the statement in the beginning that they were not going to publish advertising because they were going to print the truth.

JK: Yes. Politically, *PM* was very progressive. In terms of design, it was avant-garde for a newspaper. It also published photographers like Margaret Bourke-White and Morris Engel. It was a very good paper.

MH: It's interesting that Paul Strand reviewed *Naked City* for *PM*. He wrote in the July 22, 1945, issue that the book "takes an important place in the development of American photography as a medium of expression."

MO: I think *PM* was a very important part of Weegee's transformation, because it was there, through his association with writers and artists, that he developed a new sense of himself as one of that set. It was a very different group from, say, the daily journalists.

WN: For the *Naked City* publication party, the publisher proposed a regular Madison Avenue reception, but Weegee said, "Let's go to Sammy's on the Bowery." The proprietor of Sammy's apparently bought a thousand dollars worth of books, and the food and liquor were on the house.

JK: That may be hyperbole.

WN: Well, you're right. Yes.

CW: But Sammy's was famous as the place where the swells went slumming. The society crowd went to Sammy's and hung out with the Bowery bums.

CY: Weegee understood very well the coolness of doing that.

WN: The coolness; that's a great word for it. This was twenty years before SoHo existed, but he understood that it was a cool thing to do.

CW: Again, it emphasizes that the slob has arrived. The slob can have the swells down to his place now.

JK: When *Naked City* came out, the reviewer for the *New Yorker* in the July 21, 1945, issue certainly thought Weegee was slumming: "Weegee . . . knows what a camera is for, and how to use one to catch the life of a city, but some of his pictures, in their harsh prying into the lives of the broken, the outcast, and the poor give the impression that he gets one hell of a big kick out of slumming."

MO: There is an ambivalence in Weegee's attitude toward his subjects that you pick up in his writing about the photographs. On the one hand, he was the humanitarian who had great empathy for all these downtrodden folk, who hated the upper class. On the other hand, he made fun of the subjects with whom he was supposedly empathizing. He mocked them by his wit and made fun at their expense for the entertainment of the viewer.

DF: I wonder if the title of the next picture, *Their First Murder*, from October 9, 1941 (pl. 8), contains a little of what Miles was just referring to.

CW: The story about this in *PM* was that a man had shot a small-time hood named Mancuso and then run through these children, who were coming out of school. The cops couldn't shoot the murderer because the kids were there. This suggests that the cops were on the scene when the killing occurred, and that the gunman turned around and ran away while the cops were standing there. Again, I'm not sure that's plausible. It must have been a very gloomy fall day, because it's supposed to be 3:15 in the afternoon, but it looks much darker than that.

MO: I think this is the greatest Weegee photograph, a masterpiece. In one sense, it was just a happy accident—he was there. He had many happy accidents because he was fast and arrived at the right time. What this portrays is the mix of emotions that human beings have in the face of tragedy. You can see the tremendous and genuine grief of Mancuso's aunt in the middle.

CW: The boy partially hidden in the center, who is pulling the hair of the girl on the right, is a cousin of Mancuso's.

MO: And the kid on the left, who is happy as anything, has the most interesting expression. Each expression is different in this picture, and that's fascinating.

IR: What I think is remarkable about this photograph is that it should have been taken with a 35-mm camera.

WN: Why?

IR: Because of the spontaneity; this is an action shot. It's very difficult to focus a Speed Graphic camera, and he's fairly close here. He learned how to focus from wedding photographers. Those who used a four-by-five-inch Speed Graphic counted the number of pews; as the bride and groom hit a certain point, no matter what expression they had, they were photographed!

CW: He focused to ten feet, didn't he?

IR: Yes, but Wilcox relates that he made a general focus while walking up to the scene, then fine-focused when he held the camera up. He had great pride in his sharp focus.

MO: Having prefocused, his distance was fixed, and he only had to decide on his angle of vision.

CW: The flash is what freezes the picture. He didn't care much what the shutter speed was.

MO: The other face I love here is the one of the girl on the right-hand side who is curious, but looking with a demonic expression.

CW: I think that's because she's having her hair yanked. The *PM* caption says the boy was trying to keep his mother, Mancuso's aunt, from having to look at the body. It's very confused; again, the caption doesn't seem to match up with what's going on—whether he's trying to pull that girl so she doesn't look at the body, pull her out of the way so he can see the body, or block his mother from seeing the body.

JK: Well, the aunt is in pain while she's looking at a painful scene.

CW: I wonder whether the kid on the left had seen the camera and automatically smiled at the photographer the moment the flash went off.

IR: He's obviously trying to stand up to have his picture included in this "family gathering."

MO: In showing these individual faces expressing such varied emotions, the composition evokes—and maybe this is why the word *masterpiece* comes to mind—sixteenth- and early-seventeenth-century paintings of the Crucifixion, where the spectators are expressing different emotions or looking in different directions.

JK: It's also similar to the war photographs that people like Robert Capa were making in Europe—scenes very much like this of mothers who are hysterical, grieving over sons missing or killed in the war. It's expressionistic in the best sense of that art historical term too.

WN: Weegee's description of the way he used his equipment is interesting here. He said in his autobiography, "There are photographic fanatics. . . . [who] buy a so-called candid camera . . . there is no such thing: it's the photographer who has to be candid, not the camera." That's an important phrase. This print is presumably cropped from a four-by-five-inch negative, because in *Naked City* he said: "The only camera I use is a 4 × 5 Speed Graphic. . . . The film I use is a Super Pancro Press Type B. . . . I also use a Graflex flash synchronizer and the exposure is always the same, 1/200 part of a second stop F.16, that is, at a distance of ten feet." Weegee clearly knew technique backward and forward, like a painter or a draftsman or any artist who knows his or her materials and has complete command over the results.

CY: When you first look at this picture, you would never imagine that its title would be *Their First Murder*. It suggests the coldness of his identification with these people. It's a vicious idea: their first murder.

IR: The implication is that he's seen thousands.

CY: Right, and that these kids are young and will grow up in this world where they're going to see more.

WN: We've just looked at a picture of a corpse on the street with a gun in front of it. That's what Weegee was supposed to photograph. Did he photograph the corpse in this murder?

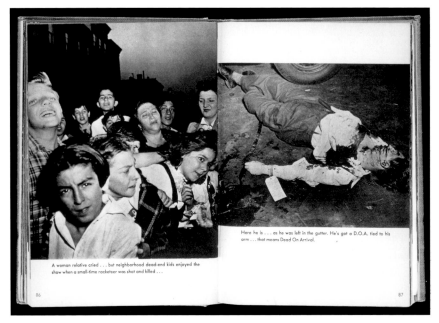

Here he is . . . as he was left in the gutter. He's got a D.O.A. tied to his arm . . . that means Dead On Arrival.

A woman relative cried . . . but neighborhood dead-end kids enjoyed the show when a small-time racketeer was shot and killed . . .

Weegee.
Naked City, 1945.

CW: Yes, Weegee took pictures of the corpse, which were reproduced in *PM* and *Naked City* (see above), but he also saw these people jockeying for position to look at the body, including the aunt who's come out of her apartment.

IR: The implication to me visually is that the children had announced this event to the woman, and they were whisking her to the scene, which makes it absolutely heartbreaking.

JK: He often photographed the wife or son or daughter as they arrived to identify the dead.

IR: Right. I wonder if he just got bored photographing bodies, and so he turned to the people who would survive the victim.

JK: To get the reaction.

MO: But the picture also relates to his being interested in human reactions, going back to watching people in the movies as they looked at scenes on the screen. He was just very interested in human nature.

WN: Miles described this as a picture full of accident, and that brings to mind the Leonardo da Vinci statement that accident and chance are the most powerful creative forces in the universe. I think we're seeing that coming into play here. What Miles was probably referring to is that there is no way that Weegee could have known that he would capture that smile, that he would have this glimpse, that the kid's hand was reaching out. He couldn't have known all of those complex interactions ahead of time.

MO: He couldn't even have seen them at the moment of exposure.

IR: But wasn't he part of the event at this point? If you look at it spatially, he was not really a voyeur, but part of the catastrophe in this person's life. Again, he's in synch. As Jackson Pollock said, "I am Nature."

MO: When Weegee talked to Stieglitz, he asked him what the mystery of photography was, and Stieglitz said it was, among other things, timing and seizing the moment. Weegee's genius, certainly evident in a picture like this, is his ability to seize the moment and to know when the moment is coming. Of course, Weegee planned many other photographs. He went up on the tenement roof to look down at the sleeper (pl. 20); there's nothing of a moment there except his deliberate choice. But there are a number of other photographs where he had the genius of the moment.

CW: In another way, this photograph is absolutely Bressonian, except that the flash gives it this horrific quality. There's always an elegance in Cartier-Bresson, who eschewed the flash. But Weegee developed a Bressonian sense of timing, aided by the flash as the tool that would freeze the scene.

DF: *I Cried When I Took This Picture* (pl. 4) is dated December 14, 1939.

CW: Miles pointed out in a very good essay in *American Art* a few years ago [Winter 1992] how really heartless Weegee is capable of being. When he uses a title like *I Cried When I Took This Picture*, my response is, "No, Weegee, you didn't. You took

that picture *instead* of crying." That shows his inability to make contact with the human misery around him and his need to rise above it by being a detached voyeur.

The anguish of these two women is so incredible. The published story informs us that two relatives of the older woman, whose name is Mrs. Henrietta Torres, are in a burning building and are clearly going to perish. The firemen haven't been able to rescue them, but that didn't make Weegee cry. He didn't allow himself to become involved in the emotions of these women; instead, he held himself aloof so he could take the picture.

JK: He even threw in a little humor since we can't tell if the fireman's hat is sitting on the fire truck or on Mrs. Torres. And the number two reminds us there are two subjects here, Mrs. Torres and her daughter.

IR: This feels a little more modern because the daughter is looking toward the camera. She is almost asking, "What are you doing here?" It's a challenge to Weegee's humanity, and he was very seldom challenged that way.

MO: The mother's expression, and the way her hand holds her kerchief, makes her look like the classic Mater Dolorosa.

CY: But the daughter is not just asking why Weegee—a photographer—would be in this situation. I think she's looking for him, and the other spectators, to help. Although the title suggests differently, there are very few photographers out in the field, in situations like this, who would ever drop their cameras and help. That distance is a requirement for the job. But I think it's fair to say that Weegee actually did think about this later—that evening or sometime later. The title does suggest he had a compassionate view about this situation at some point.

IR: But here he's in a combat zone and can't do anything about it.

CY: Right.

MO: This title has always made me wonder why we should care whether he cried when he took this picture. That's really not what's important, is it? It's almost as if he's become the subject of this photograph by virtue of his empathy.

CY: Which is such a part of many of his photographs in *Naked City*. He is the subject.

CW: Whenever he took a picture of spectators, whether they were people in a movie theater he was photographing with infrared film or people at a disaster who were looking on—perhaps involved, but nevertheless passive and watching—he identified with them because they were voyeurs. These two women are the most unwilling voyeurs imaginable, but Weegee, who was there to take pictures to sell to the press, turned his camera on them, making this mirror image. These are the people he could identify with. People involved in shootings didn't lead dull lives and live in furnished rooms. But people who were spectators—granted, in this case, they are spectators who are involved—were also voyeurs, like him, and he identified on some level. There's a creepy mirror image here, but it doesn't have to do with compassion.

JK: But it's not Warholian either. Warhol's sympathy with Weegee's voyeuristic mode is something else, but this is expressionistic. This is not a neutral gaze.

CW: No. These people are detached from the scene itself.

IR: No. We're confronted with the raw emotions of helplessness; I think it's almost overwhelming. It's looking into a private moment. It's heartbreaking even sixty-five years later.

WN: Weegee loved to play on the emotions of his audience, and in this picture he knew he had something that would do that. It's a flashback to his days of playing the violin in silent movies, when he used his skills to manipulate the viewer's emotions. I've always thought of this picture as having an exploitative element that *Their First Murder* doesn't. That is, he knew he had a picture that would sell.

CY: This image was picked up during his lifetime as a very important picture. It was first published in *PM*, then in the *Post* and in *Time*.

IR: Photographs like this are more tragedies than news events. But they stay in your mind as dramas because the artist created the basic theatrical elements.

MO: Weegee is a photographic counterpart to Nathaniel West. I've been thinking about this picture in terms of West's *Miss Lonelyhearts*, which takes place in the milieu of the tabloid press. It deals with a columnist writing a Miss Lonelyhearts column, answering letters from people who are suffering great tragedies. West

made up the letters, but they were based upon real ones that he had encountered. West's tone in dealing with human tragedy was a mixture of great compassion and detached irony, and something of that is in Weegee. It's interesting that West was also immersed in the popular culture of the time, especially the journalistic scene. They were both attracted to the spectacles of violence, disaster, and suffering that were so characteristic of this age.

A picture like this, which depicts that suffering, makes us feel not only our great empathy with the subjects but also a kind of comfortable sense of "thank goodness we're not there."

WN: Do you think that Weegee ever cried? I somehow don't imagine him as somebody who would.

CW: I can see him having a lugubrious side and being easily moved to tears in some situations. Not this one, but others.

JK: He was on the job here.

MH: In the Mary Margaret McBride interview he did in 1945, just after *Naked City* was published, she asked how he felt when he photographed a man who had been hit by a car. He said: "It was a very sad thing, I mean, sometimes . . . I cry, I mean, but I can't help it. I figure it's my job to record these things."

DF: The next several pictures take us away from Weegee's crime and tragedy work. This first one is titled *Shorty, the Bowery Cherub* (pl. 39). Shorty's hat is dated 1943, but since the cherub typically represents the new year, this is no doubt December 31, 1942.

MO: Right.

WN: The picture of Shorty reproduced in *Naked City* shows the same figure in the same pose with 1945 on his hat.

MO: Yes, it's been changed.

JK: It's darkroom work.

CW: It's either darkroom work or he did this every year.

IR: No, the two pictures are the same. Weegee probably wanted it close to the book's publication date, so he asked the retouchers to change it.

MO: This raises questions about Weegee's use of cropping, because the image in *Naked City* shows Shorty without the surroundings. It's a very different picture. This print shows people accepting Shorty as an interesting member of the group. He's a part of the party, and they're on a friendly basis with him. When he appears cropped by himself in *Naked City*, he's isolated as an aberration from the normal body type. The cropping changes the meaning from here, where he's normal, to abnormal.

CY: Do you think he's normal in this photograph? He's wearing a diaper and a funny hat.

MO: Right! He's not normal in that sense. What I mean is that he's normalized by the environment, which is at least accepting of him.

DF: Normal in the same sense as we defined for *Transvestite* (pl. 11).

MO: Yes. I think Weegee's willingness to crop suggests a malleability in terms of what he would do with his work. There was nothing sacred about the negative or the print. There's a sense of exploitation, in the best sense. He exploited his materials.

JK: We might relate this to the sleeping tenement resident (pl. 20), which was made about six months later, if 1942 is the correct date here. It's also a male figure, nearly nude, in a public place.

IR: It's interesting how the hand on the right side leads us into the subject matter.

JK: It seems so large compared to the size of the figure.

IR: Right. A device of the Italian Renaissance.

JK: Yes, exactly.

CW: It's holding back a curtain to reveal the scene.

MO: Weegee has captured the moment when Shorty's lips are just to the glass. He has that look of someone just about to drink. The glass is too close to focus on, so he's gazing out into space.

CW: One wonders whether Shorty didn't submit to this humiliation on New Year's Eve because they gave him free beer all night. He could come in and play the jester, dressed up as the Infant New Year.

MO: That thought gives the image a different possibility. I don't believe Weegee did so, but consider the possibility that he might have taken this as a poignant picture of Shorty, who was forced by virtue of his physicality to play this role on New Year's Eve. And that Weegee, the photographer, was recording this with a kind of pathos.

IR: If Weegee wanted to be empathetic with this figure, he would have gotten lower. But he maintained his position of being above, part of the crowd looking down on the figure.

CW: And he photographed at a moment when Shorty's hand was on the bar, which he had to reach up to. So even in the cropped version, we clearly see this is a picture of a little person.

DF: The title of *U.S. Hotel at 263 Bowery*, from about 1944 (pl. 18), suggests it was made close to Sammy's.

IR: I think of this as symbolic of Weegee's childhood experience in arriving in America. On Ellis Island, there was a staircase that every immigrant ascended to have his or her papers reviewed. Lewis Hine depicted it in *Climbing into America*. It was a very important staircase because the doctor was at the top. If there were any deformity or illness, immigrants would be sent back to Europe. Weegee was at a critical age when he entered America, about ten; he was old enough to know what was going on. Acceptance was based on that staircase. This image, made in a fraction of a second as he was walking from Sammy's, is a confirmation of a childhood event that was important. It's a very naked photograph that could only be done by somebody who had experienced that long passage.

JK: And the fact that it says "U.S. Hotel" . . .

IR: The norm becomes critical to an immigrant in order to have passage into the U.S. Hotel.

CW: I think you're correct that this is a self-captioning photograph about his life. A gambit of all street photographers is the self-captioning picture, where you include something in the photograph, a graphic or a line of text on an advertising sign, that makes the joke in the photograph. The famous Weegee example, of a building burning down, is *Simply Add Boiling Water* (pl. 1). He was always alert to how a casual sign might have another meaning. The idea here is that the United States is a long, endless stairway that leads you're not sure where and is narrow and confining.

JK: But there's always the possibility of going up.

CW: Yes, but you're starting at the bottom.

WN: In 1917, Weegee tells us in his autobiography, he left home and slept in rooms on the Bowery at a cost of twenty-five cents a night, spending ten cents a night more than if he slept in the dormitory. Twenty-five years later, he returned to one of these Bowery hotels as though reliving his own past. It seems very emblematic. The repetition of those words is almost like a chant.

CY: Since the U.S. Hotel was near Sammy's, he probably went by it many times before he took the picture, and afterward as well.

DF: Sometime after *Naked City* was published, Weegee began a very different kind of work in addition to his street photography. *My Mother in Law / Human Sculpture*, dated 1959 (pl. 41), is an example. Cynthia, can you give us some context for this?

CY: Weegee began doing distorted images after 1945. He used a lot of different techniques. In this case, he probably took a very straight-looking image, cut off half of it, and used a mirror, reversing part of it to get this demonic, bimorphic creature. The handwritten caption on the border of the sheet with felt-tip marker is very typical of his work.

JK: This is one of the simpler examples when compared to the range of his distortions. I wanted to include one so we could talk about this aspect of Weegee's work, although we have only three in the collection.

MO: This looks like science-fiction iconography from the 1950s.

CW: Like the pods from *Invasion of the Body Snatchers.*

JK: Yes, it does remind me of a science-fiction film.

WN: Why would he have titled it as he did when he didn't have a mother-in-law? He was married only briefly in the late 1940s.

CY: I think he was just playing on stereotypes. Captions were a whim of the moment; prints of the same image have different captions.

IR: He got a lot of enjoyment out of making these. I have always thought of them almost like Rorschach tests, but some of them can be very poetic, especially when we know the subject matter. This one, of a nude, is playing on the organic form.

CY: This is a pure creation of the darkroom. It's, quite frankly, disturbing, and also very masculine. Some of his distortions are sexy, and others are just silly.

IR: He did distorted prints of the most famous people of the time.

JK: Although in a very cynical way. Cynthia, you probably have a better reading of this, but between his continued connections with the Photo League and the cynical political caricatures he did during the 1960s, I would say that Weegee had little admiration for politicians. I don't know if he ever voted or if he took his political concerns that far.

CY: I think the fact that he distorted so many politicians is an indication that he kept his eye on politics. He distorted the Secretary-General of the United Nations, and all the Kennedy cabinet members. He was pretty savvy about the difference between what they said and what they really meant. There's a lot of play on the idea of talking out of two sides of one's mouth.

JK: Oh, yes, the one of Robert McNamara . . .

CY: A classic distortion. It has two mouths.

IR: He did many celebrities, too.

WN: As you said, Cynthia, Weegee had already started experimenting with different techniques after 1945, but they weren't reproduced in any of the publications then. In the autobiography he writes about being proud of developing what he called new picture techniques.

124

CY: The photograph we just looked at, of Shorty, was one of the images that he reworked and distorted. He elongated the image so that Shorty looks almost psychedelic; it becomes an image of an intoxicated state.

MO: Did he distort the cropped figure of Shorty or the whole picture?

CY: The whole negative. The idea that a photographer can go back and distort his own successful negatives is pretty amazing.

IR: To take a cherished photograph that had become famous and do a distortion— you have to assume he knew what he was doing, because he was putting an important image at risk.

DF: What use did he make of these? Did he ever publish or exhibit them?

CY: They were published in a lot of magazines in the 1950s.

JK: And he did several books himself, like *Weegee's Creative Camera.*

CW: I remember reading that some of the Hollywood celebrities especially liked them, so perhaps we're selling this body of work short. Perhaps his purpose with the celebrity and political distortions was to be, like Daumier, a caricaturist.

CY: Absolutely.

MO: Right, and he spoke of himself as a caricaturist. This certainly connects with the fact that abstraction was in the air in the art world at this time. What's so remarkable is that Weegee would turn from the most dramatic realism to this at the other extreme. I suppose you could say he was doing this under the influence of currents in the arts, that he was trying to ride the market. But it's a little disturbing that he would abolish the aesthetic premise of realist photography so easily and just use the camera as a creative instrument, without any backward glance.

IR: When an artist changes so dramatically, it's always interesting to try to find something that happened in his or her life. In the late 1940s, television was coming in, and journalism was changing. The number of newspapers in New York decreased, and there weren't as many venues to sell photographs to.

JK: His health may have had something to do with it. He would have been sixty when he made this print.

CY: This is speculative, but I think that ten years of looking at murders had a psychological toll. How many more disaster situations or horrific scenes could he see? The realist photographs that he took later on were parties in Greenwich Village and people hanging out in Washington Square Park. He continued to photograph people in their environment, but they were much tamer subjects.

WN: In 1947, after the film of *Naked City* was produced, Weegee decided to close his little office behind the Centre Street police station and move to Los Angeles. In the autobiography he gives this as the reason: "My life seemed to be growing stale. I was tired of gangsters lying dead with their guts spewed in the gutter, of women crying at tenement-house fires, of automobile accidents." I think what Cynthia was saying of burning out, of having seen so many terrible things, is very likely.

CW: After 1945, the tenor of the times changed. In *New York: Capital of Photography*, Max Kozloff has a very eloquent few sentences in which he talks about what he calls the three W's of the 1940s—Orson Welles, with *The War of the Worlds*; Walter Winchell, with "Good evening, Mr. and Mrs. America and all the ships at sea"; and Weegee. All of them were reflections of the hysteria of the time, the pace, the desperation, the ever-rising pitch of dread and mayhem that seemed to be part of the culture. By 1948, when Weegee was out on the West Coast, the tenor of America had changed. It was calming down after the war, building suburbs and getting ready for the 1950s.

DF: The next photograph is titled *Some Do Their Home Work There* (pl. 47) and was done before 1946.

JK: I believe this picture is completely staged, which I discovered by looking at related images at ICP. I don't know if the man at left was actually a waiter, but Weegee photographed him in three or four different positions in the room and carrying different things on his tray. And the fellow at the table on the right, in the middle ground, was posed in different ways.

MO: Was this for a story where he needed a photograph like this?

JK: I don't know, but a number below the image suggests he planned to include it in something.

MH: It was only reproduced in *Weegee's People.*

MO: It surprises me to see someone sketching in the style of Picasso in a cafe. Is she a student artist doing her homework? Is she making a sketch of the man in the white hat?

JK: That's what I've been intrigued by, because he's so well dressed.

IR: I believe so, because of the nose in the portrait.

MO: I love the way the man sitting at the table on the right—with his expression and his ears, his face and posture—looks like Picasso.

I wanted to read a couple of statements by Weegee that relate to Picasso and abstraction. This is from *Weegee by Weegee*: "One of my earliest assignments for *Vogue* was to photograph an exhibit of the work of the abstract artist Stuart Davis at the Museum of Modern Art. The way I handled abstract art was to make it non-abstract. I shot it straight. *Vogue* went for it."

WN: By making it nonabstract, does he mean being documentary?

MO: That's exactly what puzzles me. Then he says this about Picasso: "For the *Sunday Graphic,* I covered the Picasso show at the Tate Gallery. I got peeved at Picasso. That guy was imitating me . . . some nerve of him! I decided to set him straight. I straightened out his abstractions and brought them back to normal, especially his portrait entitled 'O.J.' which was a painting of his sweetheart. He had painted her with a long neck. I reduced her neck back to normal."

DF: Is he describing his distortion images there?

JK: Exactly.

MO: When he says the way he handled abstract art was to make it nonabstract, I'm not sure what he means literally, but he's talking in the spirit of the debunker of elite art who is going to speak for the populace. And when he says he brought Picasso's abstractions back to normal, there's a sense that he's going to take away the magic

of art, that he's going to unmask the pretensions of modern art and straighten them out for the layperson. It's a populist aesthetic that seems to be very deliberate.

MH: *Weegee by Weegee* included a series of eight portraits of Picasso that he distorted.

CY: After Marilyn and *Mona Lisa*, Picasso was his favorite subject for the distortions. I think Weegee was obsessed by him as a persona and tried to figure out where he stood next to him.

WN: The woman sketching in this picture suggests that Weegee had an interest in the process of making art. He put himself into places where people were making traditional works of art. He was asking himself: "What is an artist? Am I an artist?" And the distortions were heavily manual. They were not stolen from life, but were heavily worked. And remember that when he came to California he earned his livelihood by doing special effects for motion pictures. So he was very dexterous at manipulating the materials.

JK: He was a technical director on a number of films.

CW: I want to talk a bit about the relationship between the photographs of ungainly people in situations of duress, which Weegee made his reputation on, and these later grotesques that he created with distortion. Exactly what the relationship is, or what it means, is hard to say. But I think it's obvious that they are related in some ways. He often created grotesques in both situations.

What's compelling about the comparison is that it speaks of some very elemental psychological need in him that photography satisfied. It had to do with his ability to identify with either subject and yet feel an incredible insecurity in both situations. The grotesquerie is both a projection of himself on the subject and a need to debase the subject in some way. It relates to a spiritual language of his own in both situations.

IR: I think that's part of being the outsider, of coming from another location. Weegee always looks as if he is never really at home in America. Everything seems new to him. The characters and the events are seen with outsider eyes, an immigrant's eyes. He is photographing the important events of the day, but I think there's a sort of disbelief in the images.

DF: *The Fountain / Face of the Villiage*, which Weegee misspelled, is from about 1955 (pl. 42). It represents a very different kind of approach for him.

CY: This image is much earlier, but when Weegee died in 1968, he was working on a book on Greenwich Village.

DF: With the masking tape holding this print onto the backing, which has the caption and number, do you assume that this is a page from his mock-up?

JK: Yes, that was our assumption.

MH: The mock-up was auctioned off at Swann, and there were many more pictures in it than what Da Capo Press published in its posthumous edition, *The Village*, in 1989.

WN: It's worth noting that the central figures here are a couple. Throughout his self-commentary, Weegee says, with some slight regret, that he never found a mate, at least until late in life. One of the themes that runs through his work is couples observed, in nightclubs or on the street. This couple is fascinating because the man is so—I guess we could use the word *preppy*—and the woman is wearing mesh stockings and looks like a Village beatnik. The question is what kind of relationship existed between these two people, and did Weegee have any idea about their relationship.

MO: I agree. The man's pants are pressed, and his shoes are shined.

IR: He has a slight James Dean look to him.

CW: This was published in *Swank*, which was a men's magazine, in 1956. It was included in a photomontage.

WN: Is it possible that this is a fashion picture with the man as the mannequin?

MO: It could be.

JK: The photomontage has dozens of pictures in it; they're all Village images by Weegee.

CY: And they're reproduced very small, postage-stamp size. Weegee was fascinated by young people during this period. He followed them around in Central Park, looking at what they were doing and who they were talking to and hanging out with. He went to a lot of parties where the guests were decades younger than he was. I think it was an older man's desire to be in touch with the youth of the period.

MO: What I find interesting here—again, typically Weegee—are the background figures. The men on the right and left, who represent the straight middle class, seem to be looking at the couple slightly askance. On the right, the man's mouth is set in a disapproving but muted expression.

IR: This is a self-assignment. Weegee was no longer working with the four-by-five-inch Speed Graphic. Is that right?

CY: Yes, he was probably working with a 35-mm camera.

IR: Jessie Tarbox Beals worked in the Village in the early 1900s photographing its bohemian life, and what took place there in the 1950s and 1960s was almost a caricature of that original scene. What Weegee saw was not the original event, but he was able to capture the Village as a new event taking place in New York City.

JK: It would be interesting to know what Weegee really thought of the Village. He must have been aware that it had a long tradition of bohemianism, with artists, writers, and musicians living there. In the 1950s, after he started feeling more like an artist, I wonder whether he felt more like he belonged there and should get better acquainted with it.

This couple, whether they're students or not, look like the folks who would be in the audience for the film noir movies that were coming out during the early 1950s. They could have gone to see *Naked City*.

MH: Or *Rebel Without a Cause.*

JK: I wish we knew more about what Weegee's plans were for his mock-up. Someone just put the Da Capo edition together. The reproduction of this image is cropped so that the heads of the three people in the background are not seen. You just see the couple.

MO: Why would they do that? That cropping was criminal!

IR: The larger print depicts outsiders again. People in the Village who didn't fit into the norms of their parents' society were forming a small family. They were gaining power. There was a large shift taking place in America about this time, and I think Weegee was excited about that. But he was getting older, and his Village photographs were not as spontaneous. They don't have that fraction-of-a-second decision making; they are slower photographs.

CW: Part of the career path of any street photographer who lives into old age is that his pictures slow down. He can't take them on the wing anymore. He's not agile enough, and his reflexes aren't fast enough to shoot the way he had earlier. I don't know about Weegee, but often a street photographer who once prowled the streets would sit in one place and wait until something came to him. Weegee may have parked himself by the fountain and waited for an interesting subject to show up.

IR: And in Washington Square, where this was photographed, a lot of people would have passed by in a very short period.

Weegee produced art in two ways as he got older. He produced it in a very small area like the Village, picking and choosing his subject matter as he strolled, and he was in the darkroom, distorting his work, where he was also in control.

CY: The text of *The Village* is a little cynical about what Weegee called the young people of the day. On the first page, he said: "People flock to the Village to escape . . . to be different . . . or even just to be themselves and to meet kindred souls. . . . The Village is full of creative talent: painters, actors, dancers, writers, trainees . . . waiting to be recognized. However, if you meet a guy who composes songs, flies a plane, reads *The New Yorker*, cooks spaghetti, wears a bow tie and a goatee, and smokes a pipe . . . he's no genius."

IR: That reflects back to the U.S. Hotel staircase (pl. 18). He got to the top of the immigration staircase—he got into America—and he realized that many others were in worse shape than he was. "This is what I had to be normal for?!"

DF: The last photograph we're going to consider today is *Alfred Stieglitz* (pl. 49). This was made in May 1944, some two years before Stieglitz's death.

JK: He's eighty years old in this picture.

MO: This has always struck me as a very cruel photograph. Weegee portrayed Stieglitz as looking so defeated, so tired. He is sitting on his cot, the pillows ready for him to take a nap, his hands held helplessly in front of him.

CW: And wearing his cape indoors suggests he didn't have the money to pay the heating bill.

MO: Or that he's too tired to take it off. This seems so antiheroic. And it's supported, I think, by what Weegee wrote about Stieglitz in *Naked City*. He was respectful and realized this was the great Stieglitz, but he evinced an ambivalent attitude toward him. To begin with, their initial meeting on the street went badly because Stieglitz didn't recognize Weegee—had never heard of him, apparently. Weegee's revenge, I think, was to portray Stieglitz in this really debilitated state and to raise questions in that treatment about the fate of genius and the loss of power, about neglect by America. All the anxiety that Stieglitz had about his own success comes out here, and Weegee identified with Stieglitz on a level of being a kindred great photographer.

IR: In this image I think we're seeing a collision, pre–Pop Art, of high and low art. It's a kind of atomic explosion, and Stieglitz was too tired to deal with it. An important aspect here is that Weegee moved his flash to an extreme angle to cast that shadow. Photographers use a bounced flash to flatter and a raking one to show coarseness.

MO: So how do you read that?

IR: He knew it would cast that deep, Munch-like shadow behind Stieglitz. It's not flattering at all.

CW: And Weegee emphasized the glasses by casting their shadow on Stieglitz's face.

IR: Right. The flash reveals all the shadows of that piece of what looks like cardboard behind Stieglitz, showing the effects of him lying down and getting up repeatedly.

WN: We know what Stieglitz was like at this point. It was well described how he had retreated to his gallery, An American Place, and that the cot was necessary because he was so exhausted from his heart condition. People who made pilgrimages to show him pictures, interview him, or pay homage to him came away with various verbal

descriptions, but this is one of the very few images that shows Stieglitz in the way that other people described him.

Beaumont Newhall's centennial exhibition at MoMA, which closed in 1940, had two publications. The first did not mention Stieglitz, and there was such an uproar in the community that a second edition was issued. Stieglitz occupied the frontispiece, and some of his more recent works were added to the show. Weegee certainly would have, we imagine, seen the exhibition, and he was probably aware of the political controversies surrounding it. When Weegee made this portrait, he, like everyone else, would have been aware that photography had a history, and that he might one day occupy a place in it.

MO: In his own thinking, he already occupied that place. But what's important, I think, is that Weegee did know Stieglitz, and Stieglitz didn't know Weegee. And that's a tribute to Weegee. As much as I see the cruelty in this portrait of Stieglitz, I also love it because it's a portrayal of Weegee's encounter. It's a document of his meeting with real photographic greatness and fame and his feelings about that—his envy, his sense of himself.

IR: But it also is sad, because it shows Weegee's great insecurity at sitting down at the table and not being a complete member. This is not an homage.

CW: Perhaps he was also responding in a vituperative way, demeaning the subject partly because he identified with him. Aspirations may have been dawning on Weegee at this point; the world was beginning to tell him that he was an important photographer. Then when he went to see this man who was *the* most important American photographer of all time, as far as he knew, he found him this humbled. You get to the top of the U.S. Hotel stairway, and you discover it's just a landing; there's some other stair to climb. You never arrive.

JK: Stieglitz apparently told Weegee that he felt that he had been a failure.

CW: Yes, exactly. So Weegee was both seeing his own insecurities and doubts about whether he could achieve anything, and at the same time rejecting them.

MH: At the end of the chapter in *Naked City*, where this photograph appeared, Weegee wrote: "Suddenly he slumped over in pain. 'My heart, it's bad,' he said in

a whisper as he slumped over on the cot. I waited till he recovered then left quietly . . . wondering if that elusive fame I was after was worth while."

MO: There is irony here in terms of his being Weegee the Famous. He began by promoting himself as famous before he had any fame and renown. Once he thought he had this renown, he was not accorded it by someone who really mattered to him. The hollowness of that claim was made even more poignant to him.

CW: When he was creating himself as Weegee the Famous, he said, "A photograph is like a blintz; eat it while it's hot." Now he had come, as he felt himself aging and going through some transition in his life, to take a longer view of time and history. And it turned out that that view is more depressing. When you're out on the street, you can live for the moment.

DF: This discussion has been really enlightening to me. By way of conclusion, as we do in all the In Focus colloquia, I'd like to ask each of you to give us a few thoughts about any new insights you might have gained about Weegee during our conversation today.

CW: For the first time in about a decade, I've been teaching photo history again. In doing so, I've been fascinated with the way in which a lot of individual photographers' lives seem to have the same course. This is especially true of photographers who come from outside of the art tradition. They don't start out to be artists but end up being taken seriously either by others or in historical perspective, and they are included in the canon of photographers of genius, of immortal photographers. Not just people who managed, in some unknowing way, to reflect a moment in history, but people who managed to transcend that so that the work remains both a projection of that time through their eyes and also something that continues.

What has encouraged, fascinated, and intrigued me about today's discussion is that, hashing it all out among ourselves, we have arrived at a similar kind of conundrum with Weegee. He started out as this guy who was finding his way by impulse, trying to make a living, trying to find something to do with himself. He did not start out to be famous or an artist, but just to find a way to make a living at Acme. He turned himself into a photographer and created a unique photographic style, but a journalistic one. And he was a hustler, a guy on the make, Weegee the

Famous, a self-promoter; not a guy who, if we met him, we would think of as a serious person.

Little by little, his photographs endured in a way that he began to respond to himself, and, in the end, he wrestled with his own consciousness of himself as an artist. He was never able to resolve this issue, nor has photographic history done so at this point. In that sense, he seems a more and more important figure to keep in mind as history continues to unroll. He is increasingly, to me, an emblematic figure of what is unique and extraordinary about the relationship of vulgar mass culture to a high-art tradition that's much more narrowly defined.

IR: I haven't looked at some of these photographs for a number of years, and today I was impressed again that someone who died so many years ago can still bring out a viewer's emotions. I found myself looking at murder scenes and really feeling the great sadness and loss of family members, and those family members have since passed and are no longer in pain from these events. So these photographs, made with a big Speed Graphic camera that isn't even used anymore, and in this form of journalism that doesn't exist anymore, still bring out feelings for people who take the time to look at them. The fact that Weegee still continues to mean so much to young viewers, and to new viewers, is an incredible legacy of these events of so long ago.

As an artist, I think that Weegee's photographs do something very critical as pieces of art. That is, he doesn't complete them; there's not quite as much violin playing as you would think. The completion of the photographs we've seen today has been our feelings toward them, and we've all had different feelings. Weegee sets certain notes in order, and we complete the pieces with what we bring to them. That's true of any great painting—it establishes a dialogue with the next generation. Often today, we've tried to resolve issues by going back to Weegee's books, because he left us with incomplete information. We have to do the hard work of finding what took place, and some of it will never be known, as with great paintings.

WN: The Getty Museum would not have the Weegee collection that it does without John Coplans, with whom I talked hour upon hour about Weegee. I learned an enormous amount from him at a time when my own frame of reference was Alfred Stieglitz, Timothy O'Sullivan, Carleton Watkins, and William Henry Jackson. If John were alive, he would have been among us today, so I'd like to conclude my remarks

by quoting what I believe to be one of the most perceptive statements that he made about Weegee in his *Art in America* article: "Weegee belongs to a very American photographic vein, *to tell it like it is.* But the extremes to which he was willing to take this rhetoric make the viewer's complicity in it apparent. To view a typical Weegee is to have the stakes in the photographic contract very much upped, both emotionally and morally. . . . Weegee does not apologize. This private eye had a vital insensitivity that is precious. This is his fascination."

MO: When I teach the history of photography, I usually don't include Weegee, although I have taught him in other contexts, such as literature and photography. I haven't taught him consistently because of the unique quality of his work. One can establish historical structures about photography within a course, and then you have to deal with Weegee, who doesn't quite fit. And that is really a way of saying that there needs to be room for artists like Weegee who don't fit.

In some ways, what's unique about Weegee is precisely what we've been talking about in a number of different ways today—the way that he crossed from popular culture into high culture. A lot of photography makes that crossing after the fact, as a result of curators' decisions, for example, where museum inclusion automatically signals the crossing. But Weegee is different, because he made that crossing himself, in his own lifetime—with the Museum of Modern Art as a kind of catalyst.

I've gained a greater clarity today about the insecurity that was rooted in Weegee's social place as an immigrant, as well as his insecurity as an artist. And perhaps even his personal insecurity in dealing with other people and in dealing with the life that he was constructing. I think that insecurity was something he was able to turn into a strength. Perhaps unconsciously, or only half-consciously, he could use it to his advantage by letting himself empathize and feel with people who were of such a wide range of experiences, backgrounds, and, simply, fates.

CY: What has been so exciting about today's discussion is to hear how richly suggestive Weegee's images are to all of us. We have talked about everything from the formal qualities of the prints to his personal history to the socioeconomic issues that emerge from the photographs. I have been working intimately with Weegee's pictures for the last four and a half years, and I think it is too simple a classifica-

tion to label him a photojournalist. His images are more complex than just straight reporting. He cared deeply about his craft, and we can see this in the passion that he gave to both his early New York images and the later distortions. His output was prodigious—he did not stop churning out prints until the very end. He really believed in himself as a photographer and as a persona. His cultivation of "Weegee the Famous" is clearly evident in the thousands of pictures that he took of himself that now dominate the archive—Weegee with his cameras, with celebrities, with animals, with curvaceous women, with his friends at Sammy's. The importance that he saw in documenting the spectrum of New York life carried through to his resolute need to constantly turn the camera on himself. His entire life was his photography.

JK: One of the things that's occurred to me today is that Weegee is still considered something of an outsider to photography in its current status, which is as an art and as a major force in the art world. But I really think of him as an insider in that he was a very hardworking photojournalist. I think of him in the same vein as Robert Capa and W. Eugene Smith, photojournalists who were completely dedicated to and immersed in their work. They gave up their health, if not their sanity—if not their lives, in the case of Capa—to their work. So if you think of Weegee strictly in the realm of photojournalism, he is very much an insider. He certainly was the quintessential police photographer, and, as we mentioned, there were many of them by the 1930s and 1940s.

But I think he's had a much bigger influence than most of the photojournalists, including Capa and Smith, in that *Naked City* reached so many people and caused him to have a great influence not only on the East Coast but also on the West Coast, in terms of film. I was going to East Los Angeles last weekend and saw a huge billboard off to the side of the freeway—an ad for a black car on a white background—that said, in enormous letters "CAR NOIR." Weegee may not have invented the noir style, but he is thought of as embodying film noir and the noir novels. So in that sense, his influence on film and his influence on East Coast artists like Diane Arbus and Andy Warhol is great.

I think that Weegee's influence is really pervasive, and we should start thinking of him as we do Atget and Atget's portrayal of Paris. Weegee is for New York what Atget was for Paris, but his status has never been equal. I think that's

primarily because he was a photojournalist, but after all, Atget was just making documents. As we know, it has to do with scholarship and the art market. Atget was the darling of both the Surrealists and the Postmodernists, and Weegee still has catching-up to do.

MH: The other day, I was reflecting on the first Weegee photograph that I saw. As a young man, I was very lucky to have befriended the husband of a math teacher who was somewhat of a bohemian, and who owned an original Weegee. It was the picture of the chorus girl reading the book with the dust jacket that says "Apes, Men, and Morons." When I saw that, I was in my early twenties, and it obviously made a great impact on me. We've been talking today about a man who started out as a street photographer, not a photographer who went to the Clarence H. White School of Photography, and someone who became one of the first true photojournalists. As we've suggested, he was also a hustler, and that was probably the driving force behind him. Of course, when he came into the so-called aura of being an artist, it changed him. I've been thinking about the last ten years of his life, and I've wondered whether, had his health not been an issue, in the age of television and the talk shows, Weegee would have become a celebrity and been a regular on those shows because of all he'd done historically. I think we've suggested today that Weegee does, indeed, have an important part in the history of photography.

WN: Thank you. I think everybody dug deep into their reservoirs of understanding today, and the result is a collaged portrait in words that reveals a personality with greater emotional and intellectual depth than we see in the mirror Weegee held up to himself.

Chronology

1899

Born Usher H. Fellig on June 12 in Lemberg, Austria (later Zloczew, Poland; now Lviv, Ukraine), the second of seven children born to Bernard and Rachel Fellig.

1906

Bernard immigrates to the United States.

1910

Rachel and the children arrive in New York at Ellis Island, where Usher's name is changed to Arthur. The family settles on Manhattan's Lower East Side with Bernard, who is working as a pushcart vendor. Arthur attends public school and works part-time selling newspapers and then candy.

1913–16

Leaves school and begins to work at a variety of jobs, including tintype operator, aide to a commercial photographer, and itinerant portrait photographer.

1917

Leaves home at eighteen. Finds shelter in missions, public parks, and Pennsylvania Station. Works a series of part-time jobs while seeking employment as a photographer.

1918

Works at the Ducket & Adler photography studio.

1921

Is hired as a helper in the darkrooms of the *New York Times* and its photo syndicate, Wide World Photos.

ca. 1924

Joins, as a contract photographer, Acme Newspictures (later United Press International Photos [UPI]), working mostly in the lab. Buys a four-by-six-inch ICA German Trix camera on time. Performs in theaters as a violinist for silent films.

1930

Purchases a four-by-five-inch Speed Graphic camera, the preferred press photographers' tool of the 1930s and 1940s.

1932

Works in Los Angeles during the Summer Olympics as an Acme messenger and printer with George Watson and Coy Watson Jr. (see p. 90).

1934

Rents a one-room office-apartment at 5 Center Market Place (see p. 9), where he lives mostly until 1947.

1935

Leaves Acme to begin a freelance career as a photographer. Manhattan police headquarters is his favorite haunt for nightly news tips. Begins to sell his pictures to many New York newspapers and press syndicates, including the *Daily Mirror*, *Daily News*, *Herald Tribune*, *Journal-American*, *Post*, *Sun*, *World-Telegram*, Associated Press, and Wide World Photos. Around this time, adopts the nickname Weegee (from Ouija, the popular spirit board game), purportedly given to him by the women at Acme based on his ability to be at news scenes quickly.

1937

Is the subject of a photo story, "Speaking of Pictures: A New York Free Lance Photographs the News," in the April 12 issue of *Life* magazine. In December, a feature by Rosa

Weegee.
Weegee's New York City Police Department
Press Pass, 1941. Gelatin silver print,
21.6 × 16.8 cm (8½ × 6⅝ in.).
International Center of Photography, 19200.1993.

Reilly, "Free-Lance Cameraman," is published in *Popular Photography*.

1938
Buys a Chevrolet and receives his first press card and permission to install a police radio in his car. Works out of the back of the car, which he outfits with a typewriter and photographic supplies.

1940
Becomes a contract photographer on retainer to the newly formed newspaper *PM*; is given free choice of subjects. Also makes infrared pictures for the publication, for which he works until its closing in 1948. Before this time, his published photographs are usually

printed without a credit line, but when one is used, it reads: "Photo by A. Fellig," "Fellig Foto," or "Credit Arthur Fellig." After this time, his pictures, when credited, are given to "Weegee."

1941
Wins second prize at the New York Photo League's Crazy Camera Ball in April. Joins the organization and is given his first exhibition there, *Weegee: Murder Is My Business*, which opens in August.

1942
Lectures on flash photography at the Photo League School in the spring term. About this

time, begins using his wet stamp of "Credit Photo by Weegee the Famous" (see p. 144).

1943

The Museum of Modern Art (MoMA), New York, acquires five of his photographs and includes them in the exhibition *Action Photography*. Is the subject of a profile, written by the noted columnist Earl Wilson, in the May 22 issue of the *Saturday Evening Post*. Teaches a six-session course in photojournalism at the Photo League School during the summer term.

1944

Meets Alfred Stieglitz and is invited to visit his gallery and living space at An American Place. While there, makes several portraits of Stieglitz, one of which is published in the May 7 *PM*. Five pictures included in MoMA's fifteenth-anniversary show, *Art in Progress*.

1945

In June, publishes his first book, *Naked City*; Paul Strand reviews it for *PM* on July 22. Begins making photographs for *Vogue*, advertising accounts, and cheesecake magazines.

1946

Participates in the Photo League project "East Harlem Housing" for the East Harlem Community Council and presents a glass-lantern slide show at the Photo League. Publication of his second book, *Weegee's People*, in November.

1947

Marries Margaret Atwood in February. Serves as a judge in a Photo League photo hunt in August. Moves to Los Angeles in November. Lives at 6526 Selma Avenue in Hollywood.

1948

Film version of *Naked City* is released, with Weegee serving as a consultant, still photographer, and extra. Joins the Screen Actors Guild. Appears as a street photographer in the film *Every Girl Should Be Married*. Premiere of his film *Weegee's New York* (originally titled *Manhattan Moods*), about Coney Island. Represented in the MoMA exhibition *50 Photographs by 50 Photographers*.

1949

Appears in the film *The Set Up* and is also a technical advisor. Separates from Atwood.

1950

Divorces Atwood. Provides distortion effects and acts in the film *The Yellow Cab Man*. Makes five-minute black-and-white film, *Cocktail Party*. Does publicity tour of nine cities for Universal's noir film *The Sleeping City*. Makes the short films *Hollywood: Land of the Zombie* and *San Francisco* (no known copy exists of the latter). Erven Jourdan and Esther McCoy make a short documentary on him, *Weegee in Hollywood*.

1951

Appears in the film *Journey into Light*; also appears in the remake of Fritz Lang's classic film, *M*. In December, moves back to New York.

1952

Begins a series of distortion photographs of celebrities and politicians. Arrested for causing a public nuisance at a nude outdoors "camera club" shoot with famous girlie model Betty Page. Around this time, his photographs begin to appear in various men's magazines, including *Playboy*, *Photographers Showplace*, *Scene*, *Swank*, and others. In August, included in the group exhibition *Then and Now* at MoMA. Begins

Weegee and Mel Harris.
Naked Hollywood, 1955 (pbk.).

a lecture tour for the Columbia Lecture Bureau in the fall.

1953

Publication of *Naked Hollywood* (coauthored with Mel Harris), with the first appearance of his photographic distortions. Also publishes (again with Harris) *Weegee's Secrets of Shooting with Photoflash.*

1954

Works on developing his darkroom technique and inventing new equipment. His distortions begin to appear in various magazines, such as *Look, Popular Mechanics, Popular Photography,* and *Vogue.*

1955

Begins work on two five-minute films, *BOAC and Other Assorted Scenes* and *Animation: Mona Lisa,* employing color and black-and-white film. Castle Films produces an 8-mm movie, *Weegee's Camera Magic,* demonstrating his trick photography. In November, publishes article, "The Village Still Vibrates!" in *Art Photography.*

1956

Weegee is one of the subjects in Lou Stoumen's documentary film *The Naked Eye,* along with Edward Weston and Alfred Eisenstadt. Abstract nudes published in

Good Photography, 1956. Published distortions also lead to textile designs for Fuller Fabrics.

1957

Begins living with Wilma Wilcox at 451 West Forty-seventh Street. Experiments with the Polaroid camera, making largely distorted compositions. Is contributing photographer for the film *The James Dean Story*. Included in the group exhibition *Seventy Photographers Look at New York* at MoMA in September.

1958

Advises on special effects for the film *Dr. Strangelove, or How I Learned to Stop Worrying and Love the Bomb* (released 1963). Provides special photography, including his kaleidoscope movie camera technique, for the New York sequence in the film *Windjammer: The Voyage of the Christian Radich*. Appears in the film *Holiday in Brussels*.

1959

Back in Hollywood briefly to raise money for the film project "Naked Paris." Lectures in the Soviet Union in conjunction with several exhibitions held there. Uses kaleidoscope lens and other special effects on the fantasy film *The Elves and the Shoemaker*, shot in Munich. Publication of *Weegee's Creative Camera* (coauthored with Roy Ald).

1960

Spends most of the year in London, where he has a contract with the *London Daily Mirror* as a society and royalty photographer. After contract expires, works freelance for *Sunday Graphic*, the *Times* of London, the *Tattler*, and *Lilliput*. Solo exhibition, *Weegee: Caricatures of the Great*, at Photokina, Cologne, West Germany.

1961

Publication of *Weegee by Weegee: An Autobiography*. Provides special photography for the film *Shangri-La* and special effects for the film *The Magic Fountain*, in which he is also an extra.

1962

Solo exhibition at Photokina, Cologne, West Germany. Appears in the British-produced movie *My Bare Lady*.

1964

Publication of *Weegee's Creative Photography* (coauthored with Gerry Speck).

1965

Diane Arbus uses Weegee's pictures in teaching at the Parsons School of Design.

1966

Appears in the film *The Imp-probable Mr. Wee Gee.*

1967

On the occasion of his fiftieth anniversary in photography, makes two short films, *Fun City* and *The Idiot Box* (the latter being random shots taken from a television screen). Included in the group exhibition sponsored by George Eastman House, *Photography in the Twentieth Century*, at the National Gallery of Canada, Ottawa, in February. Included in the group exhibition *The Camera as Witness* in Montreal for Expo '67 in April.

1968

Dies in New York on December 26.

Project Editor	Dinah Berland
Editor	Gregory A. Dobie
Designer	Jeffrey Cohen
Production Coordinator	Stacy Miyagawa
Photographers	Christopher Allen Foster
	Rebecca Vera-Martinez
Research Associate	Michael Hargraves
Printer	Hemlock Printers Ltd.
	British Columbia, Canada
Bindery	Roswell Bookbinding
	Phoenix, Arizona